Helpful Hints

Think of these as practice projects. You are learning as you paint. Practice each flower or fruit on a surface such as a piece of wood, candle, old book, clay pot, plastic storage bin, or slate. Paint for the fun of it.

Be patient with yourself. Practice makes the difference. If you are not happy with what you have painted then just re-paint it! Rubbing alcohol removes areas of dry acrylic from sealed wood, or simply allow the paint to dry and paint over. Do it again, and again, until you are satisfied.

Trace and transfer painting guides, as you need to use them. As you practice you will find very quickly that you can freely paint many of these projects. Just transfer the large fruits, birdhouse, old boats, ribbons and areas where you feel you need structure. This will allow you to adapt these designs to fit any piece of furniture, wall, or surface. You can paint the whole world.

Be generous with your paint. I have found that I can paint with a very light touch if there is enough paint in my brush. Texture in your paint is a good thing. A little texture will keep your colors bright and creates the shape of a petal. More Paint. More Paint.

Pull your brush through various colors on your palette without mixing them. The colors will form a "Mingled Mess". Mingled paint will create streaks that are more realistic in leaves and flowers.

Practice, Practice, and Practice some more.

Good paint brushes are a must.

It is vital that you clean your brush often while you are painting. Frequent cleaning will keep paint from drying up in the ferrule of your brushes and ruining that great shape that is helping you paint beautiful flowers.

If you are consistently unhappy with your results buy a new brush.

Designs can be painted on almost any surface as long as you used the right materials. Get busy and practice on everything in sight. Remember you can not ruin a flowerpot.

Painting on Candles

Wipe the candle with rubbing alcohol. Lightly rub candle with a dry paper towel.

DecoArt has a new candle paint medium that works great. Just pick up a little with your paint for the first layer of color. You need not use it in the shades and highlights on top of dry paint.

Paint JW Right Step waterbase varnish on the finished candle.

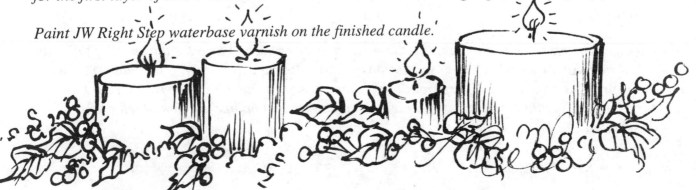

Painting on Old Books

Paint old books right on the old cover surface if you like the color.

If you want to change the color, paint a coat of **Gesso** *on the outside of the entire book. Let dry and paint any acrylic base color you like. Paint the edges of the pages with* **Emperor's Gold***. Varnish with* **JW Right Step** *waterbase varnish.*

Basic Wood Preparation.

Fill any holes with **JW Wood Filler** *and let them dry completely. Sand level. I have used* **White Lightning** *as a base coat on all my pieces as it is also a great sealer. Leave the whitewashed effect of* **White Lightning** *or add another coat with acrylic color. Let the base coat dry completely and then sand lightly with fine sandpaper or a brown paper bag. The final finish should feel smooth but not slick to the touch. If you have wood with lots of knots then first seal the wood with* **J. W. First Step Wood Sealer** *to prevent bleeding. Always read and follow the directions on the label.*

Pre painted or finished wood can be sanded lightly and it is ready to paint your designs. Wonderful things can be painted on old furniture without refinishing or basecoating. Sand the existing surface, wipe off dust with a damp paper towel and create treasures.

Varnish completed pieces with **JW Waterbase Varnish***. Re-varnish as necessary to protect them.*

Tin or Galvanized Metal

I have had fun painting on unpainted tin and galvanized metal. Just sand lightly and paint your design.

When a base color is desired the surface must be clean and free of rust. Sand lightly to rough the surface and then spray with a metal primer. Allow primer to dry and paint with two coats of acrylic (spray or brush on) of the desired base color.

Pre-painted metal surfaces, such as mailboxes, should be sanded lightly then painted. Varnish your completed pieces with **JW Exterior Waterbase Varnish***. Re-varnish as necessary to protect them.*

Transferring Patterns

Trace pattern on to tracing paper. Position the tracing paper pattern on the surface and anchor in place using masking tape. Place graphite paper underneath the tracing paper pattern with dark side down. Transfer basic lines by retracing the pattern using a stylist or ballpoint pen. I like to use a red ballpoint pen so I can see which lines I have traced. Always check as you get started to see that the lines are transferring properly. Take your time; a clear, crisp pattern is worth the extra few minutes.

DecoArt Americana Acrylic *paint is used on all of these projects. I love the thickness of this paint and the brilliant colors. I have used* **DecoArt Faux Glazing Medium** *with the paint on some of these projects to achieve transparent effects and to aid in blending. I used* **Candle Painting Medium** *and* **Textile Medium***. If you prefer another brand of paints you should refer to a conversion chart.*

Wet Palette

Place a sheet of deli-wrap on top of several layers of wet paper towel in a tray or stay-wet box. Squeeze paint out on to damp deli-wrap surface. Paint will stay workable all day. Cover your paint and it will keep for days. The damp surface will keep the paint fresh but will not dilute your paint or allow it to skin over and get gunky. Purchase deli-wrap at party paper stores, warehouse clubs or at your local deli.

Definitions

Basecoat - *To apply the first layer of color.*

Shading and Highlighting - *To apply color on top of the basecoat, both dark and light, to give dimension to your painting.*

Detailing - *To add fine lines, flower centers, stems, and other touches to give a finished look to your painting.*

Tapping - *To tap very lightly using the tip of the brush, bouncing around rather than moving in straight rows. Use this technique to create foliage or flowers.*

Double Load Brush - *Having two colors in your brush at the same time. First pick up the darker color on the heel of the brush then brush several strokes across the edge of the lighter value loading the point of the brush. Brush in the same places each time you pick up color. The desired effect is the have pure color on each edge or corner of the brush and a gradual blending of the two colors in the middle of the brush. I like to have more of my light value and less of the dark in my brush so that the light value will show more and the dark will not take over. I pick up the light value twice as often as the dark.*

Transparent - *Painting with color that has been extended either with water or medium so that you can see through it.*

Antiquing or Glazing - *Used to tint areas of your painted piece to tone and soften. See Creating Special Effects.*

Spattering or Fly Specking - *To tone and soften your painted piece with tiny dots of color.*

Painting Flowers

I fill my brush full so that I can stroke and tap with a light touch to achieve a delicate look.

Practice the flowers on tracing paper first. Make a notebook of your flower studies.
Paint background foliage first with Avocado, Evergreen, Olive Green, and Blue Mist. Let it dry. Pattern on top if you feel more secure but try to free hand these flowers using your pattern only as a visual guide for positioning. Paint main flowers next, add leaves, filler flowers and stem and squiggles. Put these flowers together as they please you. Remember you are painting your own gardens.

Hydrangea

Hydrangea blossoms are large ball shaped flowers composed of clusters of four petal blossoms. The colors range from blue to pink to purple. In the fall they turn pink to gray green with tints of mauve. They dry beautifully.

I painted them with a filbert brush with the brush size determining by the size of the blooms. Colors will be determined by the shades you want to achieve. Start with a cluster of dabs of the darkest value paint. Pick up **Titanium White** with some of your base color and create three and four petal blossoms on top of base color. Extend over the edges and place flowers at different angles. As you create the clusters of flowers vary colors by picking up pinks, lavenders, and blues. Add stems and large leaves with shades of green. Notice that the large ball shapes are seen at different angles and some seen from the side look like ovals. New blossoms are light green and are painted to look like little dots with a few four-petal flowers.

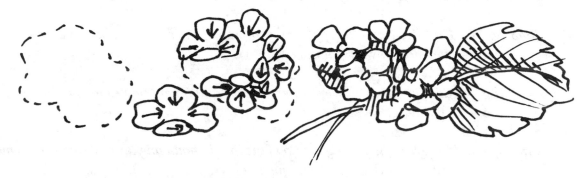

Lilacs, Stock, Purple Salvia

Paint these flowers with a round or filbert brush (size is determined by the size of the flower) by pulling through colors and **Titanium White**. Apply dabs of color. Pull brush through the edge of more **Titanium White** and paint four petal flowers on top of the base of color. Vary the color and shape of these cluster flowers.

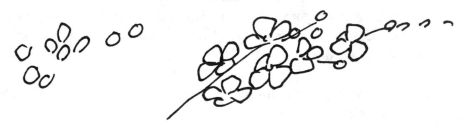

Delphiniums

Delphiniums are tall spiky flowers of pinks, purples, blues and white. Paint flowers with the tip of a round brush or filbert brush. Touch down on the tip of the brush with the handle straight up. Pull and give the brush a little flip. Tap a cluster of base color into tall shapes. Paint little flower shapes on top of base color with basecolor and **Titanium White**. The colors I have used as basecolors are **Dioxazine Purple**, **Royal Fuchsia**, **Olive Green** and **Blue Violet**. Paint little stems and dots with **Olive Green** using a 10 x 0 liner brush.

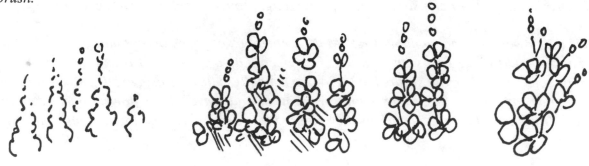

Copyright © 1999 Susan Scheewe Publications Inc.
13435 N.E. Whitaker Way - Portland, Or. 97230
PH(503)254-9100 Fax (503)252-9508

"Gran's Magic"

BELLS, BOOKS & CANDLES

*Remember the wonderful old movie with Jack Lemon and Kim Knovac, **Bell, Book Candle**? Try painting with hard work, practice, giggles and a bit of good magic might just happen.*

Surfaces you can paint are everywhere. There are wonderful candles in every store and tucked away on a closet shelf. Pick up old books at the Salvation Army or any thrift store. The bells are a little tricky these days but I'm sure you can conjure up a few.

I encourage you to paint on anything you can find. The more you paint the better and, magically, the better you will paint.

Ros Stallcup
1436 Lakeview Drive
Virginia Beach, Va. 23455
757-464-4974 Fax 757-464-4185
E-mail: Stalcop@aol.com

Supplies

All painting supplies can be purchased at your local art and craft stores. Some may be found in hardware stores. Whenever possible I have listed source information.

Paints

I have used DecoArt Americana Acrylic paints. Colors are listed in each project and always refer to the color pictures. Similar colors will work. It doesn't have to be exactly the same shade. Make your own color charts. Put your color samples alphabetically in an inexpensive address book. Take your book with you to classes where paints are supplied and add those colors too.

Brushes

Suzie's Foliage Brush is a hog bristle brush cut on an angle. All other brushes are soft synthetic hair.

Flats Shaders - #4, 6, 10 & 16
Rounds - # 2 and 5
Liner - #0
Angular Shaders - 3/8" and 1/2" (Scheewe Angular Shader, S8008 Martin/F. Weber)
Filberts (Cat's Tongue) - # 2, 4, 8 & 12
Oval - 1/2" & 3/4"
Suzie's Foliage Brush - 1/2" & 3/4" (Scheewe Foliage Angular, S8037 Martin/F. Weber)
Lettering Brush - 1/8" # 580 Winsor Newton
Fan Brush 2/0 (#916 Stan Brown's Arts and Craft)

General Supplies

• Water Container
• Masking Tape (3M)
• Acrylic Palette Paper
• Brown Pigma Pens (.01)
• Black Pigma Pens (.01)
• Paper Towels
• Stylus or a Red Ink Ballpoint Pen
• Tracing paper
• Graphite paper - White and Gray
• Sandpaper
• Plastic T-square
• J.W. Wood Filler
• J.W. First Step Wood Sealer
• J.W. White Lightening
• J.W. Right Step Waterbased Varnish

Sources
Taylors Arts & Crafts
800 Carbon City Rd.
Morganton, NC
828-584-4771

Stephs' Folk Art Studio
2435 Old Philadelphia Pk
Smoketown, PA 17576
717-299-4973

Sources

Stan Brown's Arts and Craft
13435 N E Whitaker Way
Portland, OR 97230
800-547-5531
Fax 503-252-9508

Susan Scheewe Publications
13435 N E Whitaker Way
Portland, OR 97230
503-254-9100 Fax 503-252-9508
http://www.scheewe-publications.com

Pesky Bear
15059 Roszyk Hill Rd
Machias, NY 14101
716-942-3250

DALC Woodworking
1004 McKinley Ave
Chesapeake, VA 23324
757-420-0042

Cutting Edge
P.O. Box 3000-402
Chino, CA, 91708

Hibiscus

*Paint with 1/2" or 3/4" oval brush. Paint one petal at a time highlighting while the paint is still wet. Paint petal with **Cadmium Orange** and **Royal Fuchsia**, pull through **Titanium White** with your dirty brush to overstroke the edge of the petal. Keep the handle of your brush straight up so that you are painting with just the tip of the hairs. Use a sweeping up motion. Pull overlapping stroke around the edge of the petal always pulling toward the center of the flower. Pick up touches of **Cadmium Yellow**, **Titanium White**, **Royal Fuchsia** and **Cadmium Orange**. Deepen center area and separate petal with **Napa Red** and **Faux Art Glaze**. Paint stamens with **Cadmium Yellow**.*

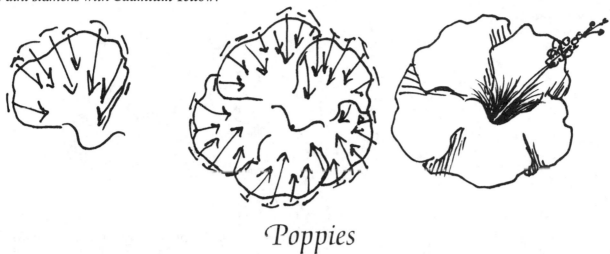

Poppies

*Paint poppy petals with **Cadmium Orange** using 1/2" or 3/4" oval brush. Overstroke the petals with **Cadmium Orange** and **Titanium White**. Add touches of **Napa Red**, **Titanium White** and **Cadmium Yellow**. Stand brush handle up straight and flick from the outer edge of the petal toward the center of the flower. Let dry and deepen the color around the center and between petals with a corner loaded 1/2" angle shader using **Faux Art Glaze** in the heel of brush and **Napa Red** in the point.*

*Paint the center of the flower with **Olive Green** and shade along the bottom edge and around the middle with **Avocado**. Paint lines and dots with **Dioxazine Purple** and **Paynes Grey** using a liner brush.*

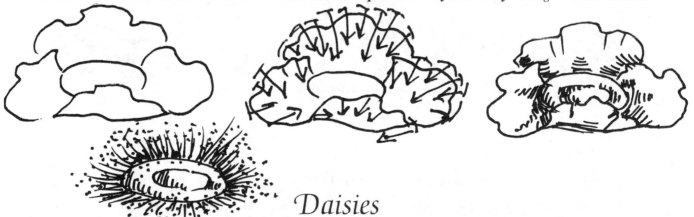

Daisies

*Use either a round or filbert brush. Brush size will vary according to the size of your petals. Most of my daisies are painted with a #2 round brush. Load your brush by pulling through the puddle of **Titanium White** several times. Start your daisy with the center, touching down with the side of the brush to form an oval. Pull each petal in from the edge as in the illustration, starting with the tip of the brush handle straight up. Push down on the brush and pull toward the center, lifting as you pull. Vary the length of your petals. Petals #1 and #2 are the longest. Complete all your daisies; add calyxes and stems using one of your shades of green. Paint centers with **Cadmium Yellow**. Shade lower section with a mix of **Cadmium Yellow** and **Burnt Sienna**.*

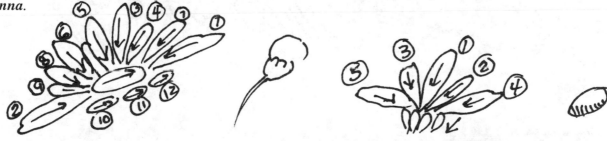

Distant Hollyhocks

*Hollyhocks are tall spiky flowers. Start by painting ovals with **Antique Mauve** and **Titanium White** using a small round brush. Create flowers by painting oval shapes with lighter shade of **Titanium White** and **Antique Mauve** on top of some of these shapes. Turn flowers in different directions and add a few dots to create tips of flowers. Tuck little leaves at random in and around the flowers using the tip of your round brush with **Avocado** and **Evergreen**. Paint stems with **Olive Green** and **Blue Mist** using a 10 x 0-liner brush.*

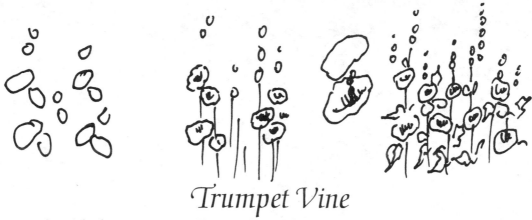

Trumpet Vine

*Paint sprays of squishy leaves to create Trumpet Vine foliage. Paint the foliage very dense in some areas and open in others. Vary colors and transparency of leaves. Paint the buds and open flowers using the chisel edge of a filbert brush with **Cadmium Orange**, **Berry Red** and **Titanium White**. Pick up more **Titanium White** and overstroke one edge. Paint four petal flowers over the end of some of these buds to create open flowers. Deepen the centers with **Cadmium Orange**. Shade a little deeper in the center and under the edge of the petal with **Brandy Wine**. Paint stems, squiggles and calyx with **Olive Green** and **Avocado**. Note that blooms are in clusters on the vines.*

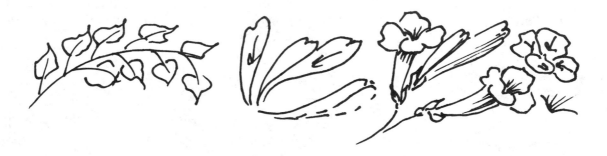

Queen Anne's Lace

*Paint Queen Anne's Lace with your 3/4" foliage brush. Tap loose oval shapes with **Olive Green**. Add some taps of **Blue Mist** along the lower edge and on one side. Tap **Titanium White** over this base of color; do not cover the entire base. Paint dots and four petal flowers at random over the white areas. Paint stems with **Olive Green** (adjust the color for contrast by adding **Pineapple**, **Lemon Yellow** or **Avocado**). Spatter with **Titanium White**.*

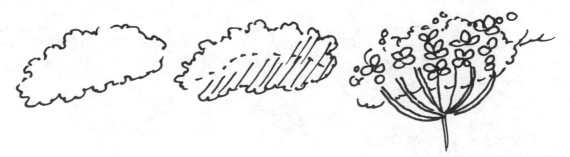

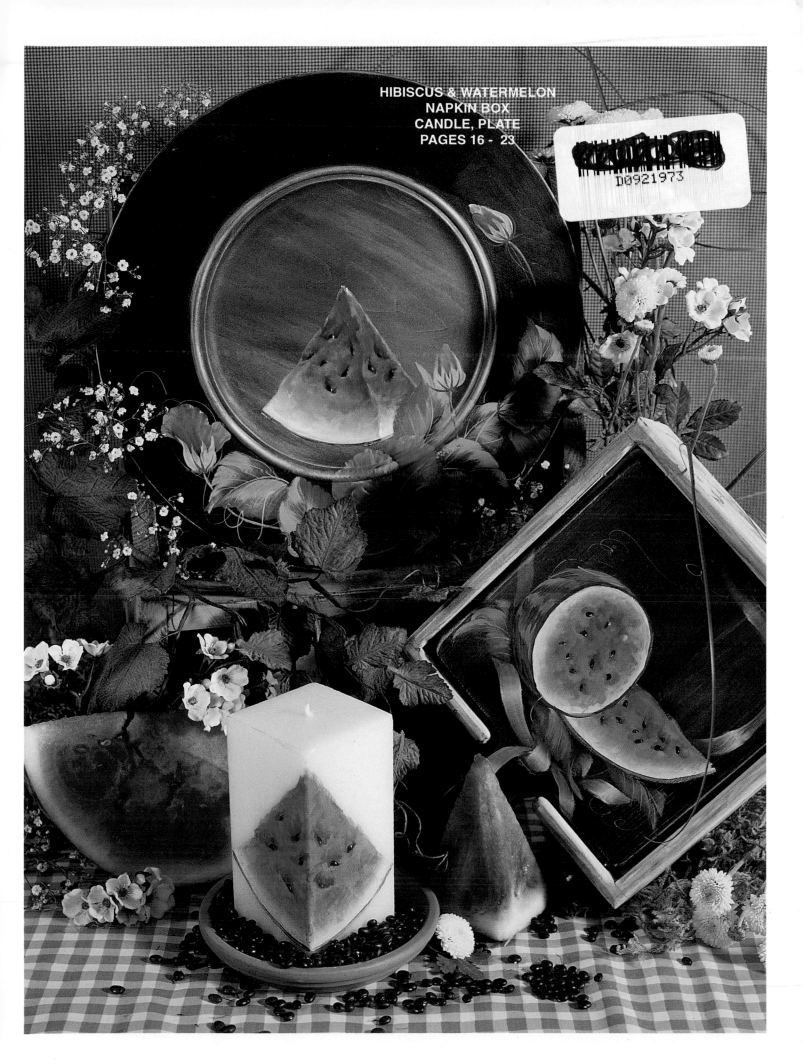

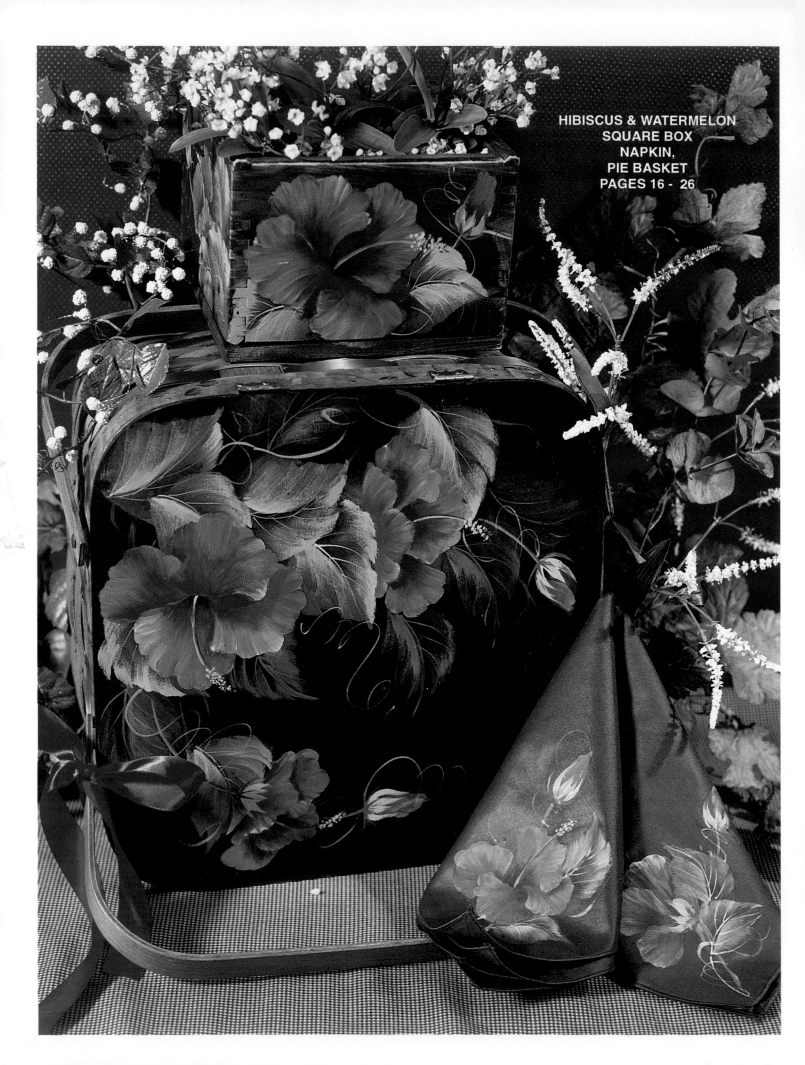

HIBISCUS & WATERMELON
SQUARE BOX
NAPKIN,
PIE BASKET
PAGES 16 - 26

Black Eyed Susans and Sunflowers

Black Eyed Susans and Sunflowers are similar. Sunflowers are much larger and the centers grow to be huge by late summer as the seeds ripen. As the centers grow the petals twist and curl. Many of the heads turn downward. Black Eyed Susans have puffy centers that sit up. Overstroke the petals with two strokes to give the illusion of the fold in the petal.

*Paint flower centers and petals with **Antique Gold** using a round or filbert brush. Tap centers with **Burnt Umber** and **Burnt Sienna** using a few hairs on the tip of 1/2" Foliage Brush. Strengthen color at base of center (and in the middle of the center on the Sunflowers) with **Paynes Grey**. Highlight the center with a few taps of **Emperor's Gold**. Overstroke the petals with **Cadmium Yellow**, allowing some of the base color to show. Highlight some of the petals with **Lemon Yellow**. Paint scattered dots with **Paynes Grey**.*

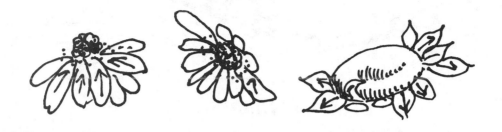

Basic Leaves

*Basic leaves are a sloppy triangle shape. Base in leaves with **Avocado** using your angle shader. Darken one side of the center of each leaf with **Evergreen** using the point of your angle shader. Highlight with **Olive Green** and **Blue Mist**.*

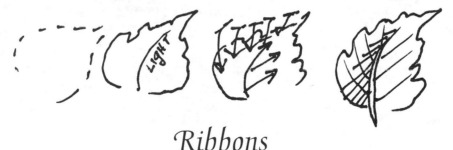

Ribbons

Paint ribbons any color you wish to complement your design. I used a 1/2-inch angle shader brush. Select two values of a color. Base in ribbon with the lighter value and Glazing Medium. Start with the brush up on the edge, point up, pull and flatten brush. Lift back up to the edge of the brush, pull and flatten again. This will make the ribbon look as if it turns and twists. Practice, Practice.

You can create simple bows and streamers using this same method. Pick up your paint by pulling the flat of the brush through fresh paint. Pick up your paint often so that it will flow as you pull your brush. Remove strokes with a damp paper towel if it gets away from you and simply do it over again. Highlight ribbon in widest places with double loaded brush with base color and white. Shade narrow places with double loaded brush with base color and dark value. Brush highlight and shading color across the ribbon.

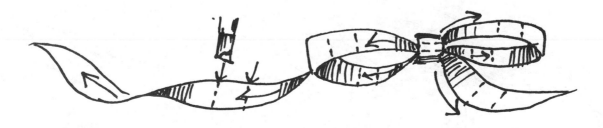

Squishy Leaves

These leaves are called squishy leaves because you create them by simply squishing the paint from underneath your brush. Paint squishy leaves with any combination of shades of green using a flat brush. Remember, you must have a generous amount of paint in your brush for it to squish out to form this leaf. Touch brush into Faux Art Glaze and fresh paint, turn brush and pat again, tip one edge into another shade of green. Paint leaf by pushing the flat of the brush sideways across the surface, lift up to the chisel edge of the brush in the center of the leaf and slip forward to make a slight point. Practice, Practice, and Practice. Pick up more Faux Art Glaze to create transparent leaves. I usually paint three leaves together and add a stem with a liner brush.

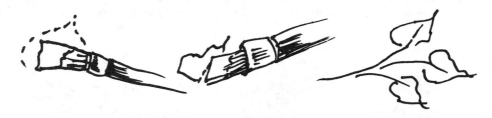

Branches

*Paint branches with a wash of **Burnt Umber** using your liner brush. Load brush fully with water and paint. Work brush in paint to load and roll back to a point. Start branch at largest end, apply pressure, and pull toward smaller branches. Wiggle your brush slightly as you pull to create small twigs.*

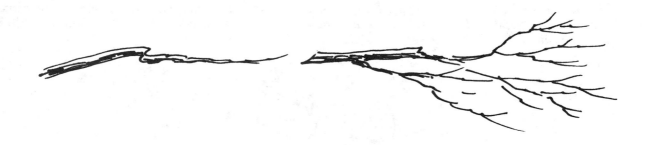

Stems and Squiggles

Paint stems and squiggles with your liner brush. Pick up your paint with a little water; pull your brush through the paint a few times to load it fully with this wet mixture. Balance your brush hand on your other hand. The handle of the brush should be pointing straight up. Touch only the tip of the brush to the surface and use a delicate, light touch.

Pull the tip of the brush toward you applying as little pressure as possible. This will create a narrow fluid line something like ink from a pen. Practice swirling the brush by stiffening your wrist and moving your entire arm to form squiggles.

Foliage and Trees

Tap foliage with Suzie's Foliage Brush (3/4-inch Scheewe Foliage Angular Brush, No. S8037, Martin F. Weber) and any of your shades of green. Soak brush in water for a few minutes before using to let the hairs of the brush fluff out. Tap bristles on your palette to open hairs. Tip only the front half of the hairs into fresh paint and tap lightly on your palette. The point of the brush is up and tip the handle forward so as to use only the forward hairs. Tap gently on the surface to create foliage. Many light taps are best, turning the brush in different directions. Stop when you have created a nice lacy appearance.

Paint tree trunks with **Burnt Umber** and a little water, using your No. 0 Liner Brush. Start with the trunk and lift up to form branches.

Painting Fruit

Start all of the large fruits by painting a basecoat. Highlight the base coat with **Titanium White** and the base color by loading the heel of 1/2" angle shader with **Titanium White** and the tip of the brush with the base color. Pat with the flat of the brush keeping the point of the brush with the base to the outer edge of the fruit. Allow colors to dry between layers. If you get carried away, simply add some of the base color. Glaze fruits with **Faux Art Glaze** in the heel of your brush and pigment in the point. Touch the heel of brush into **Glazing Medium** and slide the tip of brush across the edge of pigment a couple of times to load paint half way across the bristles. The first glazing color goes all the way around the fruit. Each color thereafter covers less of the area. Look closely at the color step-by-step directions.

Glaze over entire surface at least two times as you add layers, this will give depth to the fruit. Glazing medium does not extend the drying time. It can be removed by wiping off with water while it is still wet. Once a layer is dry the next layer will not lift the color. Paint each layer quickly, let dry and add another layer. If you paint begins to feel sticky allow to dry and add more layers. Sometimes you need to have a little more paint in your brush so that the surface dries slower. Learn to stop. Leave some of each color showing.

Berries

Paint these berries with a cotton swab. Sue Scheewe taught me this technique some years ago and I have had more fun painting them. It works great for blackberries, raspberries, holly berries, small grapes, pyracantha berries, and bittersweet. Let your imagination work for you. For smaller berries pull some of cotton off the end of your swab. (Inexpensive cotton swabs work great as they usually have less cotton the tip.) Touch cotton swab into Faux Art Glaze and roll the tip in your fingers to reshape it before taping in the paint. Touch one edge into a color and tip the other edge into another. A hole should form in the middle of the berry. As the swab gets ragged on the edges roll the edges back into shape on the palette. My little granddaughter, Paige, uses her fingers so now I also paint "finger berries". To create large berries try tapping into paint with the ends of wooden dowels of various sizes. Be generous with your paint and tap into various colors.

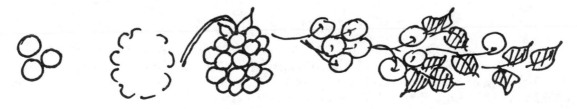

Strawberries

*Undercoat berries with **Titanium White** on dark backgrounds. Paint base coat of **Cadmium Orange** on all Strawberries using an angle shader (size determined by the size of your berries). Highlight the center of each berry with **Titanium White**. Paint diagonal lines with **Titanium White** using your liner brush across the berries, forming diamond shapes to create the segments for the seeds. Paint little curved lines to round the corners of segments. Paint seeds with **Olive Green** and paint a little line down the left side of each seed with **Evergreen**. Allow to dry. Glaze the berries with **Faux Glazing Medium** and **Cadmium Orange** all the way around the outside of each berry. Allow each layer of glaze and color to dry before adding another layer. Glaze **Berry Red** across the top, down the left side and across the bottom of each berry. Glaze **Napa Red** across the top and across the bottom of each berry. Paint caps of each berry with small squishy leaves using **Avocado**, **Evergreen** and **Olive Green**. Strengthen the color in a few places on the left side by glazing with **Black Plum**. Accent some berries on the right side with **Olive Green** to create some unripe berries.*

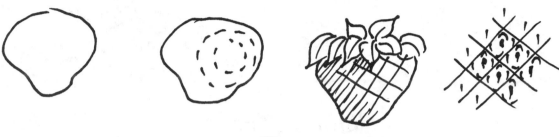

Pears

*Undercoat pears on dark backgrounds with **Titanium White**. Paint with **Cadmium Yellow**. Highlight with **Titanium White**. Glaze pears first with **Antique Gold**. Progress to darker values using **Raw Sienna**, **Burnt Sienna**, **Cadmium Orange** and **Olive Green**. Strengthen highlight with dabs of **Titanium White** and **Lemon Yellow**. Paint stem with **Burnt Umber** and highlight with **Raw Sienna** and **Titanium White**. Spatter with **Emperors Gold**.*

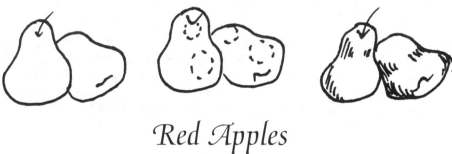

Red Apples

*Undercoat apples with **Titanium White** on dark backgrounds. Paint with **Cadmium Orange**. Highlight with **Titanium White** and **Cadmium Orange**. Glaze with **Berry Red** and **Napa Red**, **Cadmium Orange**, **Olive Green**, **Black Plum** and **Dioxazine Purple**. Paint stems with **Burnt Umber** and **Titanium White**. Spatter with **Emperors Gold**.*

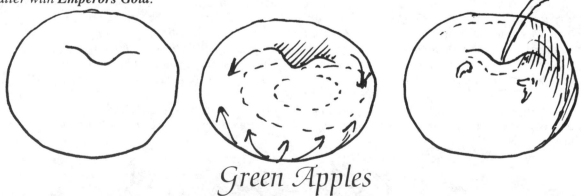

Green Apples

*Undercoat apples with **Titanium White** on dark backgrounds. Paint with **Olive Green**. Highlight with **Titanium White**, **Olive Green** and **Lemon Yellow**. Glaze with **Blue Mist**, **Lemon Yellow** and **Cadmium Orange**. Deepen stem or blossom end with **Evergreen**. Paint stem with **Burnt Umber** and highlight with **Burnt Umber** and **Titanium White**. Spatter with **Emperor's Gold**.*

Lemons

*Undercoat lemons with **Titanium White** on dark background. Paint with **Cadmium Yellow**. Tap highlight with **Titanium White** and **Lemon Yellow** using a foliage Brush. Tap more **Cadmium Yellow** on lower edge. Allow to dry and glaze with **Antique Gold**, **Raw Sienna** and **Olive Green**. Re- highlight with **Titanium White** and **Lemon Yellow**.*

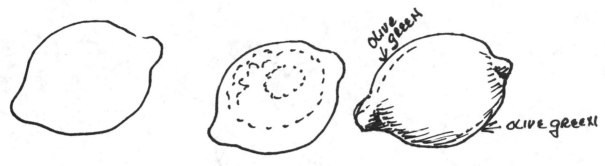

Watermelons

*Undercoat watermelons with Titanium White on dark backgrounds. Paint with **Cadmium Orange**, **Royal Fuchsia** and **Titanium White**. Double load your 1/2-inch angular shader with **Titanium White** on the point and **Cadmium Orange** and **Titanium White** on the heel of the brush. Brush across the outer edge to create the rind. Paint the edge with **Evergreen**. Put in a few darker areas for seeds with **Faux Art Glaze** and **Napa Red**. Paint seeds with **Ivory Black** and highlight with **Titanium White**. Lighten a few places in front of the seeds to set them in with **Cadmium Orange** and **Titanium White**. Keep shapes irregular.*

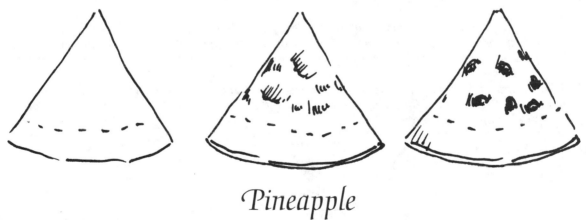

Pineapple

*Paint pineapple leaves with a flat brush using **Avocado**, **Evergreen**, **Olive Green**, **Blue Mist** and **Glazing Medium**. Base coat the pineapple with **Antique Gold**. Shade the edges with **Avocado** and **Evergreen**. Paint diagonal lines across the fruit each direction with **Evergreen**. Glaze around each section with **Avocado** and **Evergreen**. Highlight segments with strokes of **Cadmium Yellow** and **Pineapple**. Strengthen colors as needed with **Evergreen**.*

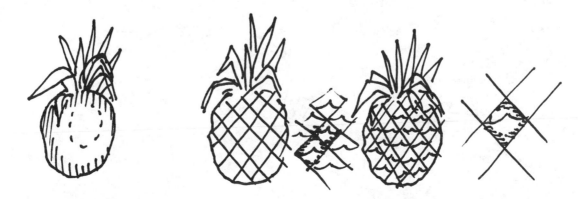

Grapes

*I painted these grapes with **Cadmium Orange**. Shade with **Black Plum**. Accent wedge shape with **Berry Red**. Highlight with **Cadmium Orange** and **Titanium White** on the right side. Paint **Country Blue** on the left side. Paint bright **Titanium White** shine highlights. Paint stems with **Burnt Umber** and **Raw Sienna**.*

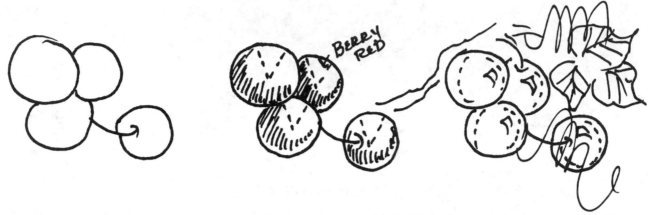

Creating Special Effects

Antiquing or Glazing - Used to tint areas of your painted piece to tone and soften. Pick up color with Faux Glazing Medium and brush over areas. Color should be transparent but create a slightly misty effect. If you have too much glaze, wipe off with a damp cloth. Allow to dry. Colors can be layered for all types of special effects.

Spattering or Fly Specking - Thin your paint with a little water. Use an old toothbrush or any stiff brush you have. Hold brush close to the surface and pull bristles back with your finger to make spatters of paint fly. Always test first on a scrap. Use colors from your design.

Verdigris or Patina - Use a large flat brush and **Bronze**, **Colonial Green** and **Teal Green**. Pick up one color and then another. Brush lightly following the direction of the wood. To create a tarnished bronze or copper effect try tapping with a sea sponge.

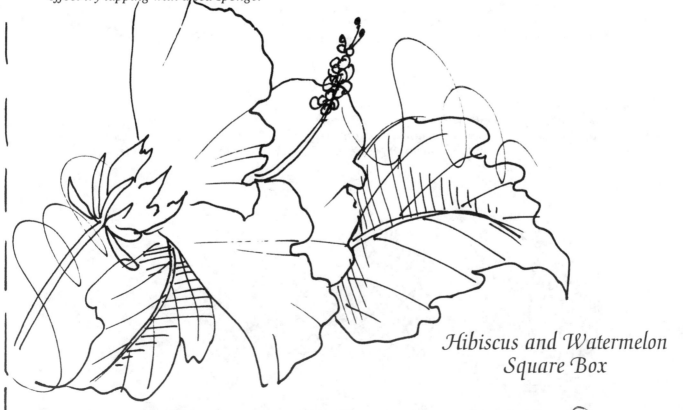

Hibiscus and Watermelon Square Box

Hibiscus and Watermelon

Surfaces: Wooden Plate (Steph's Folk Art Studio) Candle, Pie Basket (Stan Brown's Art and Crafts/Pesky Bear) Napkin Box (Cutting Edge) Square Box (McCall's Country, 31197 Wingate Rd., Sedalia, MO 65301-0815 Phone 815-829-2040), and Napkins.

Paints: **DecoArt Americana**

DA001 Titanium White DA010 Cadmium Yellow
DA014 Cadmium Orange DA052 Avocado
DA056 Olive Green DA064 Burnt Umber
DA082 Evergreen DA148 Emperor Gold
DA151 Royal Fuchsia DA157 Black Green
DA158 Antique Teal DA165 Napa Red
DA178 Blue Mist
Faux Glazing Medium

Basecoats: Wooden Plate, Pie Basket - Stained with **Min wax Special Walnut, Black Green** on top of basket and rim of plate. Napkin Box paint sides with **JW White Lightning**, top **Black Green**. Square Box - **Black Green**.

Pattern: Trace and transfer pattern as needed with white or gray graphite.

Leaves: Base leaves with **Avocado,** highlight with **Olive Green** and **Blue Mist.** Shade with **Evergreen.** Paint veins with **Olive Green** and a little **Titanium White.**

Hibiscus: Paint flowers one petal at a time. Paint petals with various mixtures of **Cadmium Orange, Royal Fuchsia** and **Titanium White.** Using a #12 filbert or 1/2" oval brush; pull strokes toward the center of the flower and while still wet, pull dirty brush through **Titanium White** and base color and highlight the edges of the petal. Deepen the value in the center and separate the petals as needed. Paint a long stamen with **Cadmium Yellow** using a liner brush. Add dots with **Cadmium Yellow** and three **Napa Red** dots on the end.

Watermelon: Base watermelon with various mixtures of **Cadmium Orange, Royal Fuchsia** and **Titanium White.** Pick up **Titanium White** on the point of 1/2" angular shader and paint along the rind. Paint rind with **Evergreen.** Paint seeds with **Black Green** and add a little **Titanium White** highlight. Let dry. Deepen areas behind seeds with **Faux Art Glaze** and a little **Napa Red.** Glaze along rind with **Faux Art Glaze** and a little **Olive Green.**

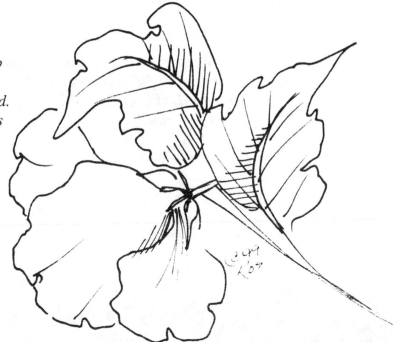

Stems and Squiggles: **Olive Green,** and **Emperor's Gold.**

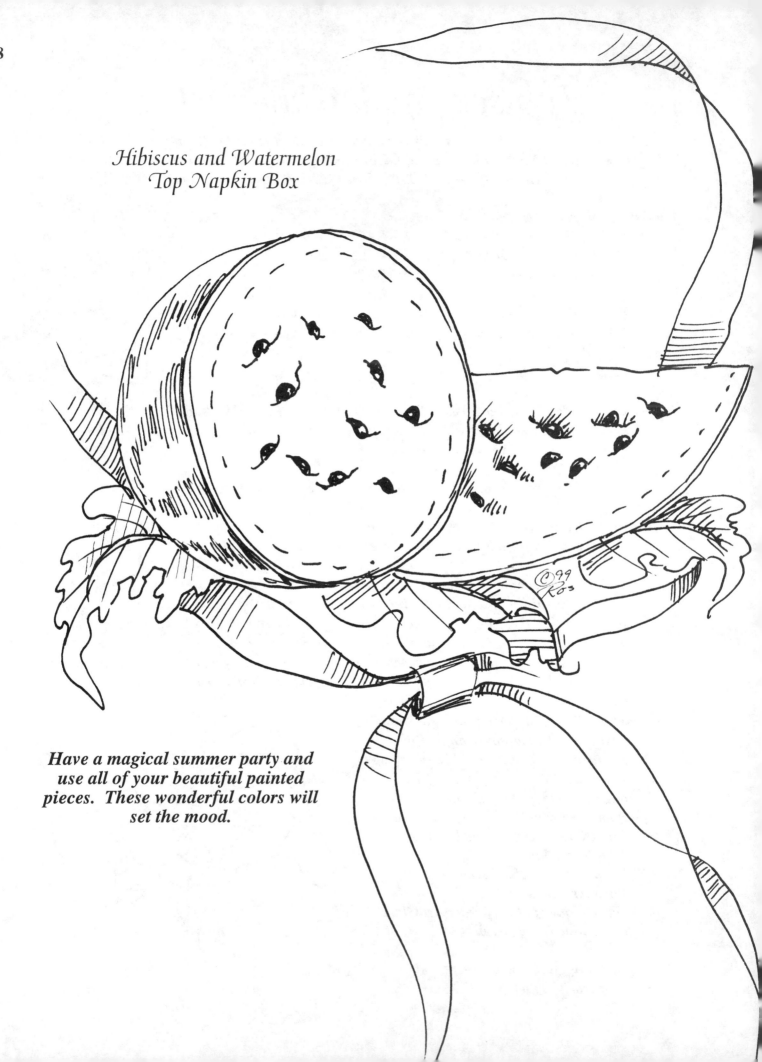

*Hibiscus and Watermelon
Top Napkin Box*

**Have a magical summer party and
use all of your beautiful painted
pieces. These wonderful colors will
set the mood.**

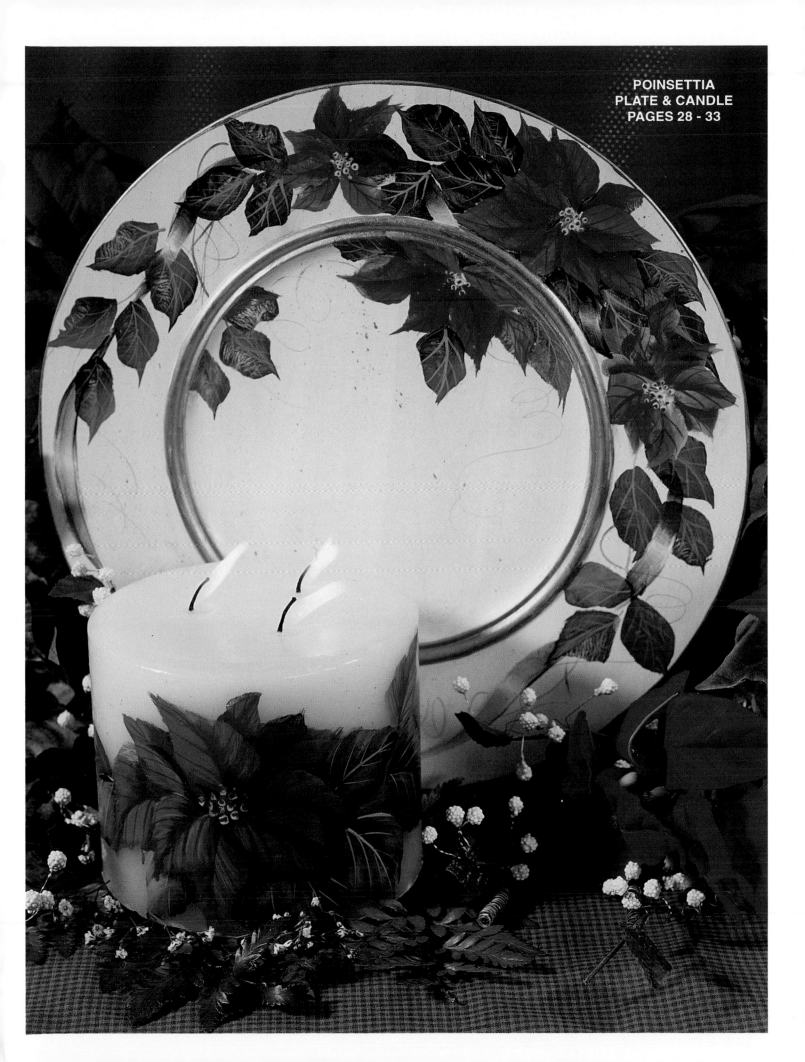

**POINSETTIA
PLATE & CANDLE
PAGES 28 - 33**

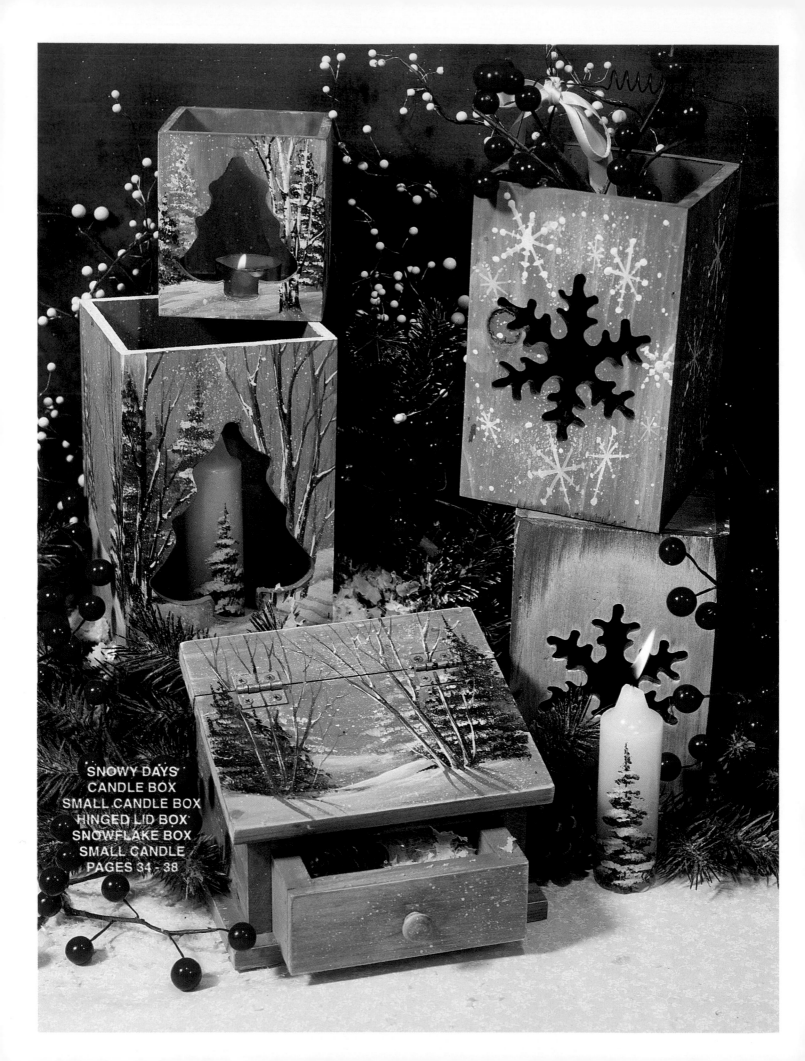

SNOWY DAYS
CANDLE BOX
SMALL CANDLE BOX
HINGED LID BOX
SNOWFLAKE BOX
SMALL CANDLE
PAGES 34 - 38

Hibiscus and Watermelon
Square Box

Hibiscus and Watermelon
Square Box

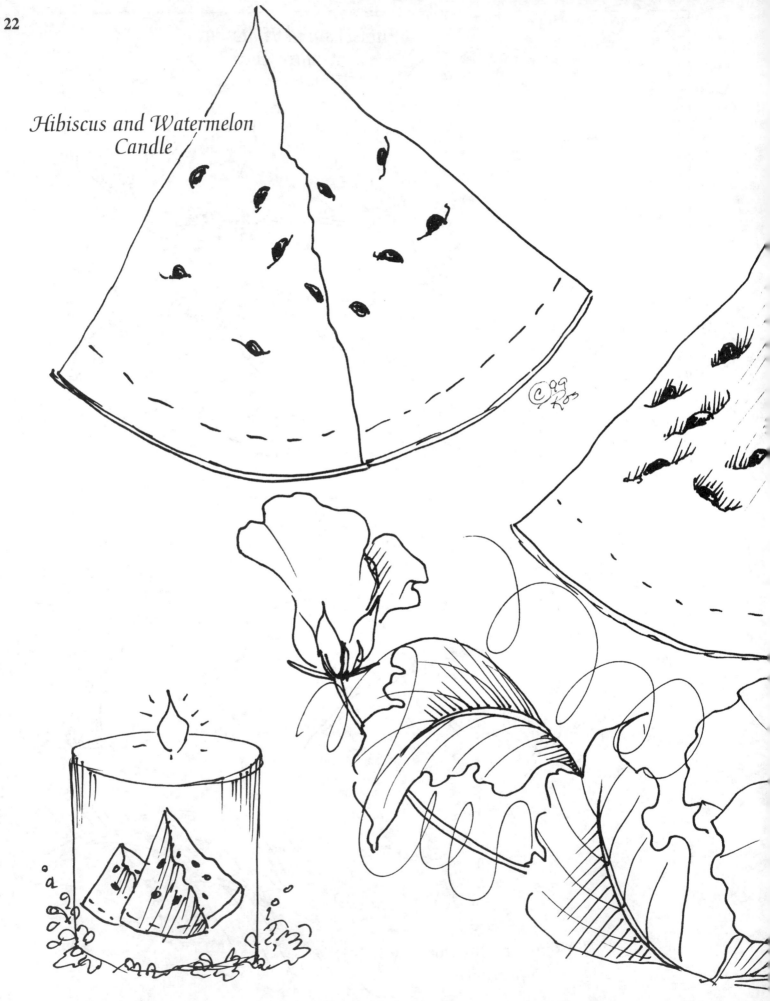

Hibiscus and Watermelon
Candle

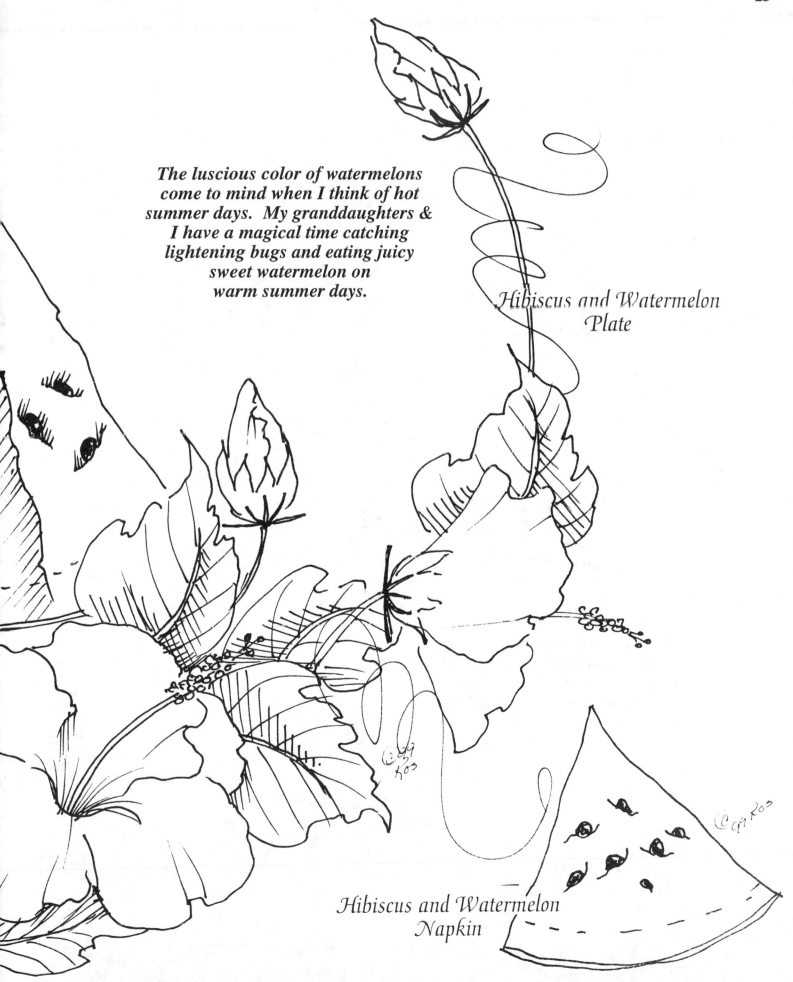

The luscious color of watermelons come to mind when I think of hot summer days. My granddaughters & I have a magical time catching lightening bugs and eating juicy sweet watermelon on warm summer days.

Hibiscus and Watermelon
Plate

Hibiscus and Watermelon
Napkin

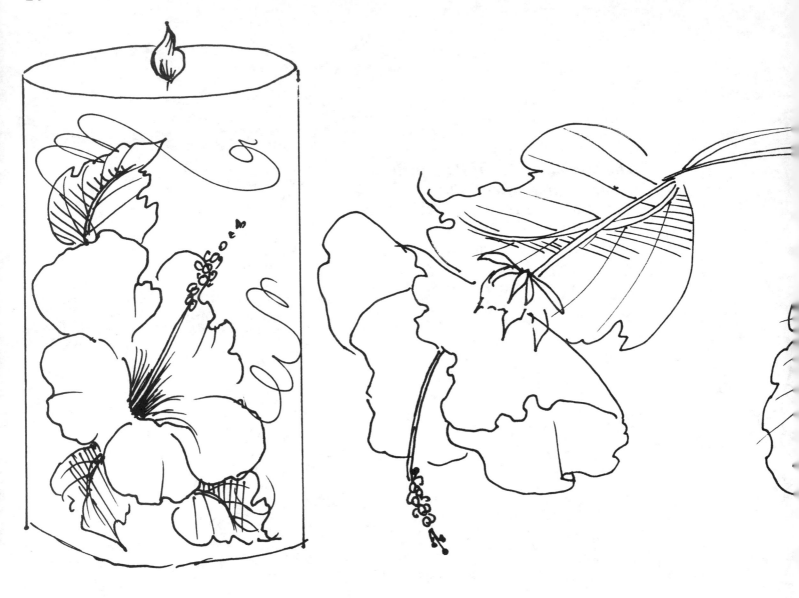

*Vary the base color for these flowers
by pulling your brush through the
puddle of different colors of paint.
Pick up paint often and do not mix
on your palette.*

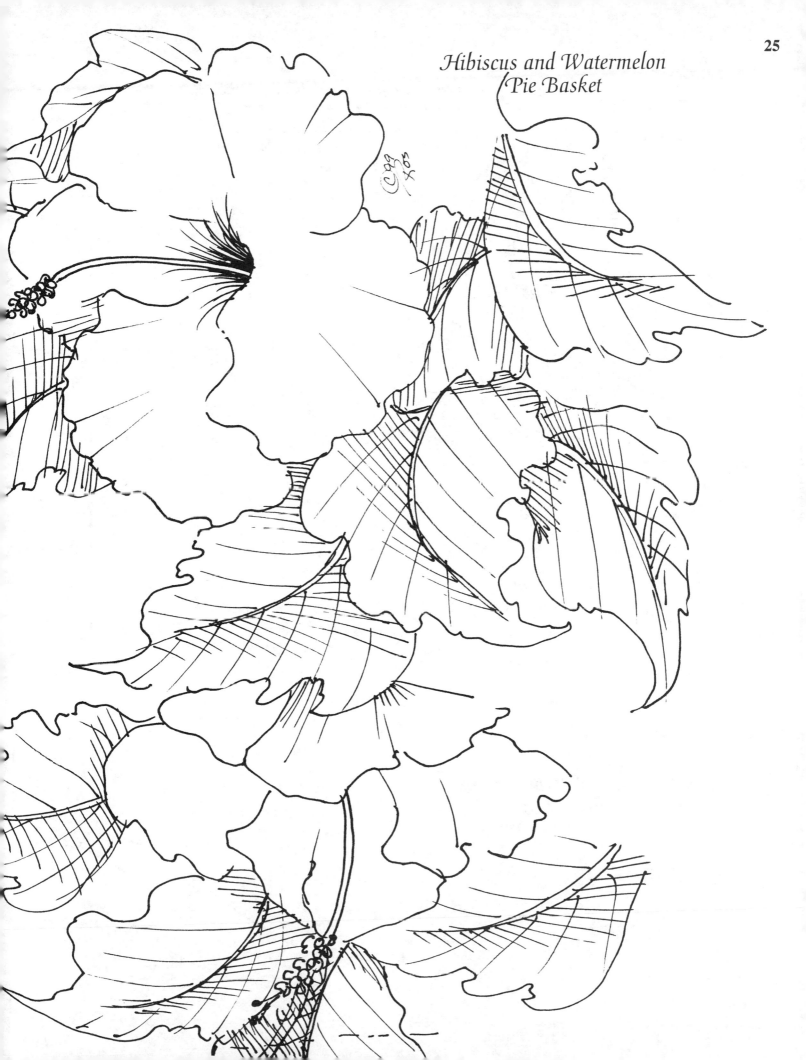

*Hibiscus and Watermelon
Pie Basket*

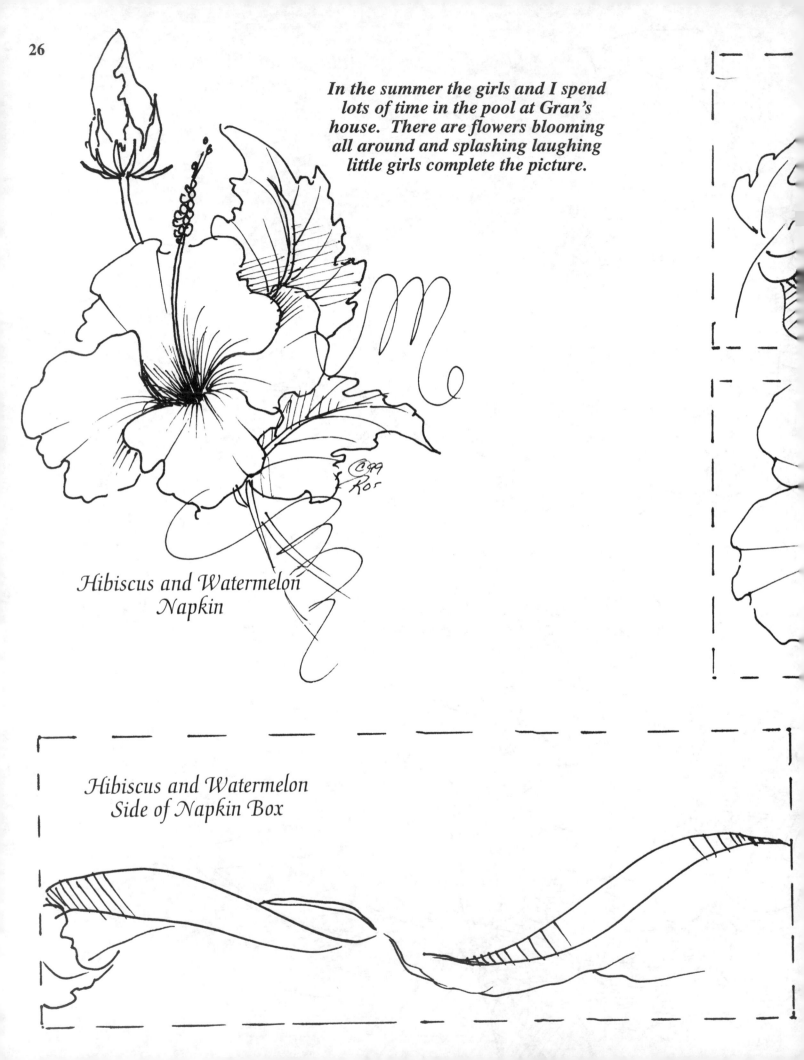

In the summer the girls and I spend lots of time in the pool at Gran's house. There are flowers blooming all around and splashing laughing little girls complete the picture.

Hibiscus and Watermelon Napkin

Hibiscus and Watermelon Side of Napkin Box

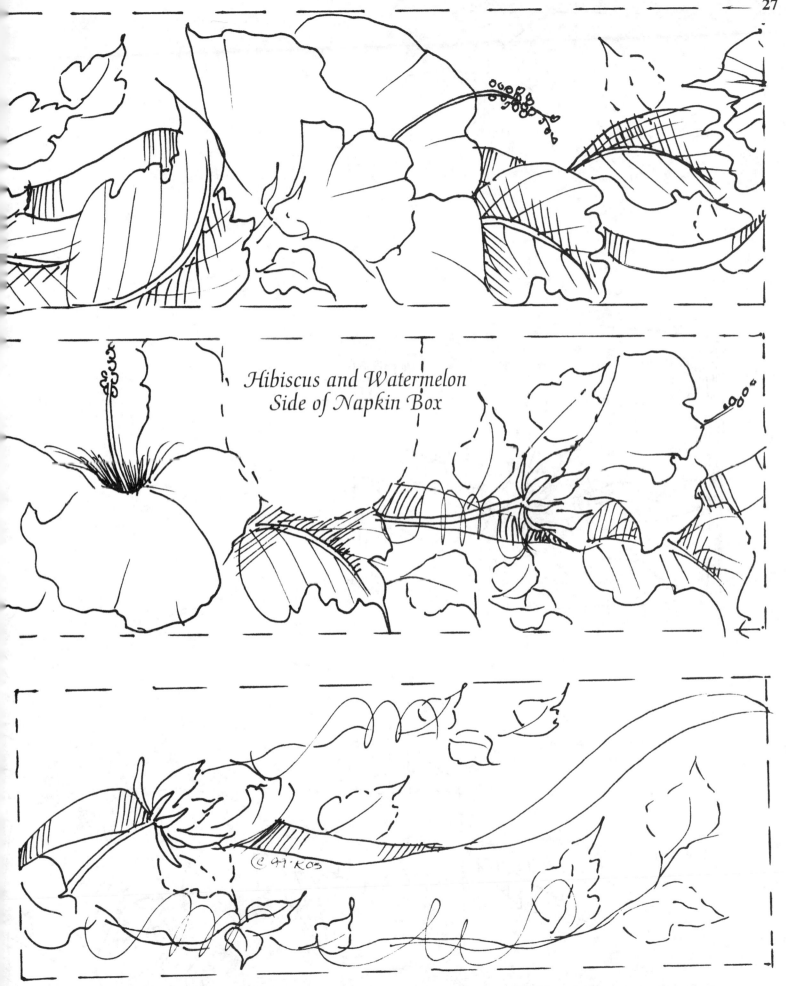

Hibiscus and Watermelon
Side of Napkin Box

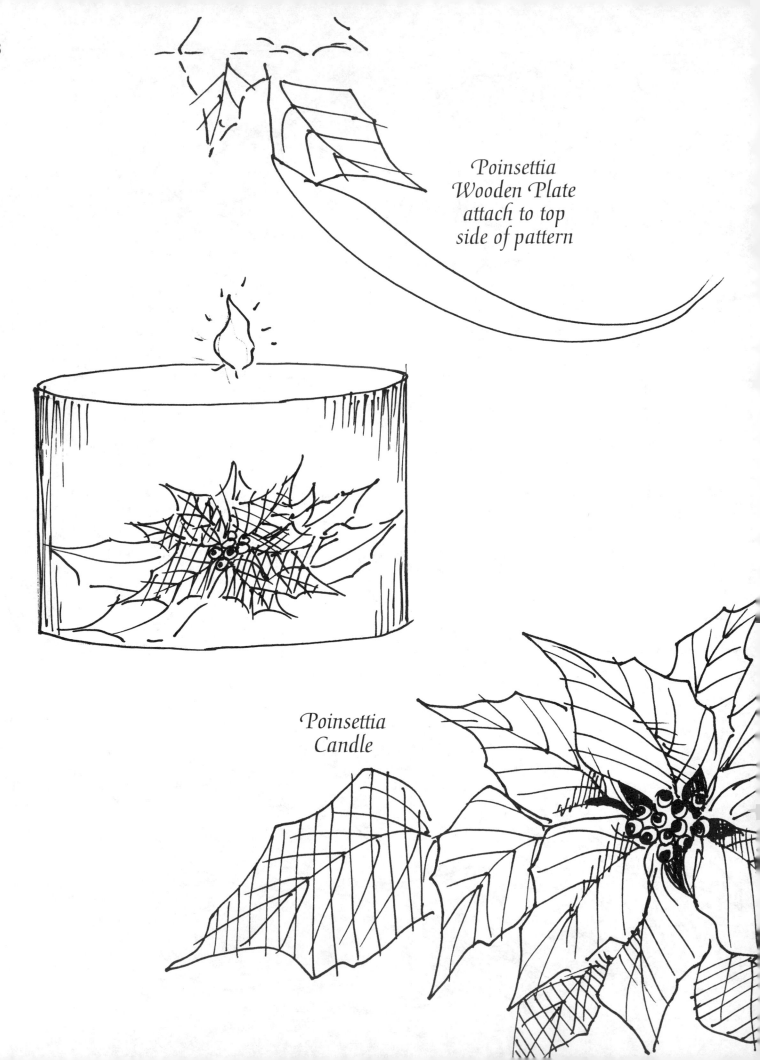

Poinsettia
Wooden Plate
attach to top
side of pattern

Poinsettia
Candle

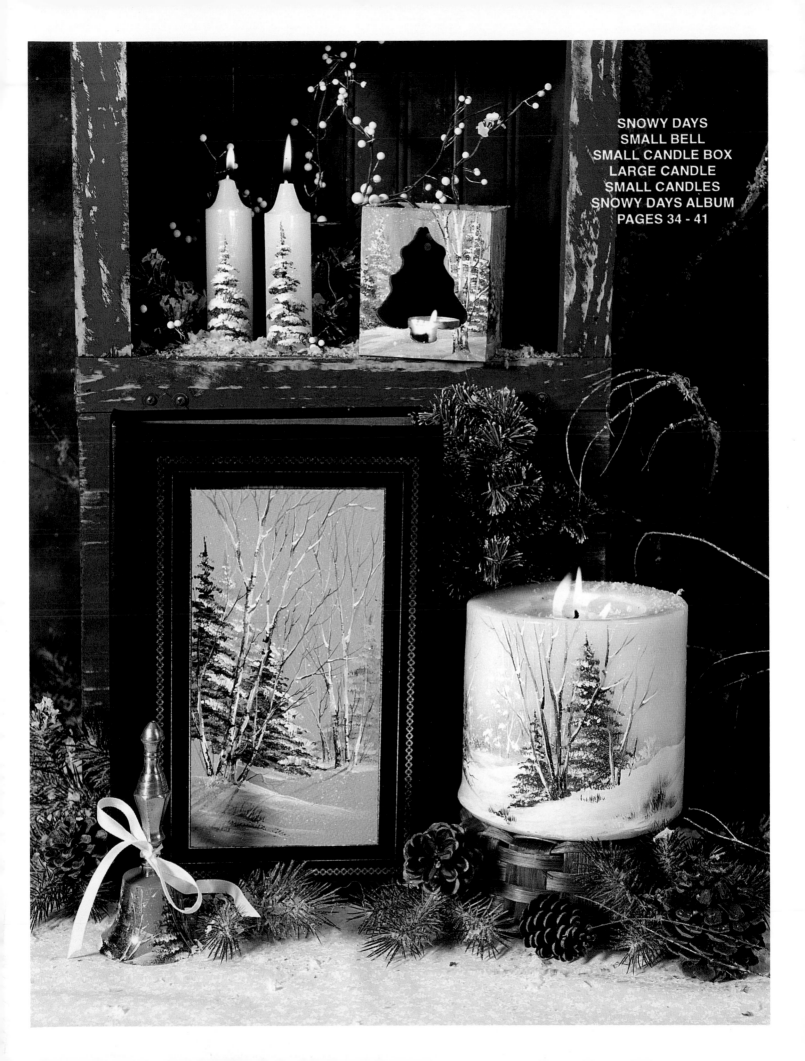

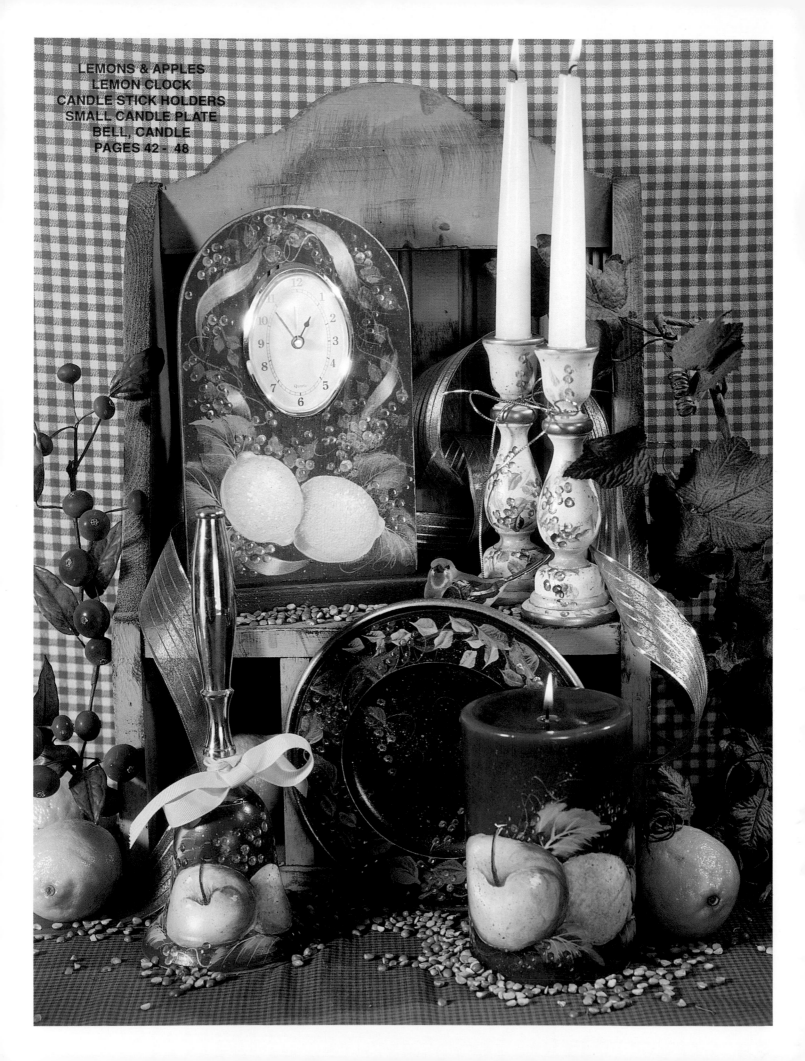

LEMONS & APPLES
LEMON CLOCK
CANDLE STICK HOLDERS
SMALL CANDLE PLATE
BELL, CANDLE
PAGES 42 - 48

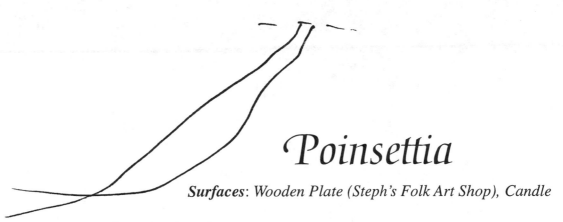

Poinsettia

Surfaces: *Wooden Plate (Steph's Folk Art Shop), Candle*

Paints: **DecoArt Americana**

DA001 Titanium White	*DA010 Cadmium Yellow*
DA014 Cadmium Orange	*DA019 Berry Red*
DA052 Avocado	*DA056 Olive Green*
DA082 Evergreen	*DA148 Emperor Gold*
DA151 Royal Fuchsia	*DA158 Antique Teal*
DA165 Napa Red	*DA178 Blue Mist*
Faux Glazing Medium	

Basecoat: *J.W. White Lightning*

Pattern: *Trace and transfer painting guide as needed.*

Leaves: *Base leaves with* **Avocado**. *Highlight with* **Olive Green** *and* **Blue Mist**. *Shade with* **Evergreen**. *Veins:* **Olive Green** *and a little* **Titanium White**.

Poinsettia: *Paint flower petals with* **Cadmium Orange**, **Berry Red**, **Royal Fuchsia**, *and* **Titanium White**, *vary colors. Paint veins on petals with* **Berry Red** *or* **Napa Red**. *Glaze over some petals to separate them from each other with* **Faux Art Glaze** *and* **Napa Red**.
Centers: **Cadmium Yellow** *dots with* **Berry Red** *dot on top.*

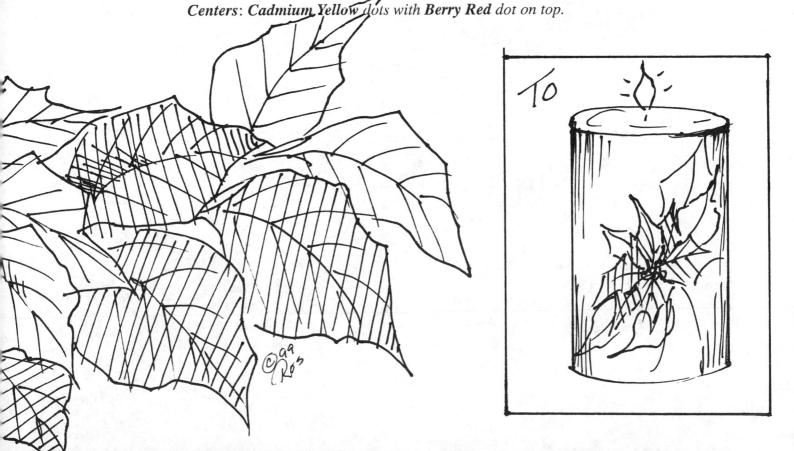

32

Your Invited

Each Christmas I place several large poinsettias together on a large coffee table and I plan to add this plate and candle to complete the arrangement.

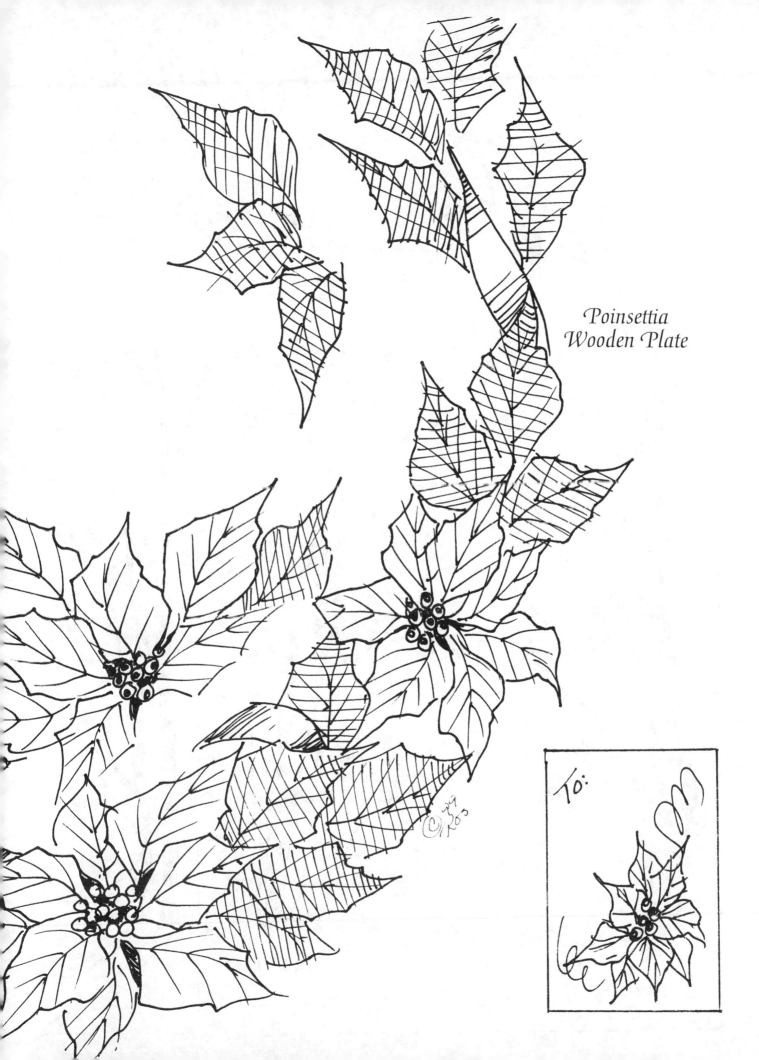

Poinsettia
Wooden Plate

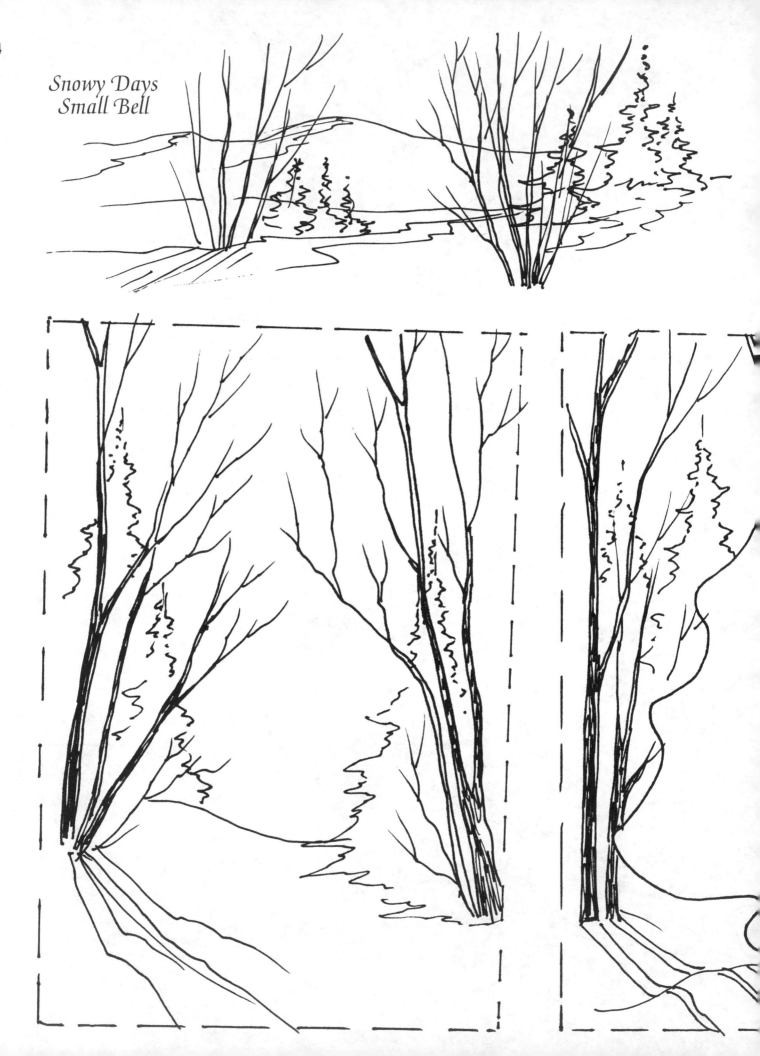

34

Snowy Days
Small Bell

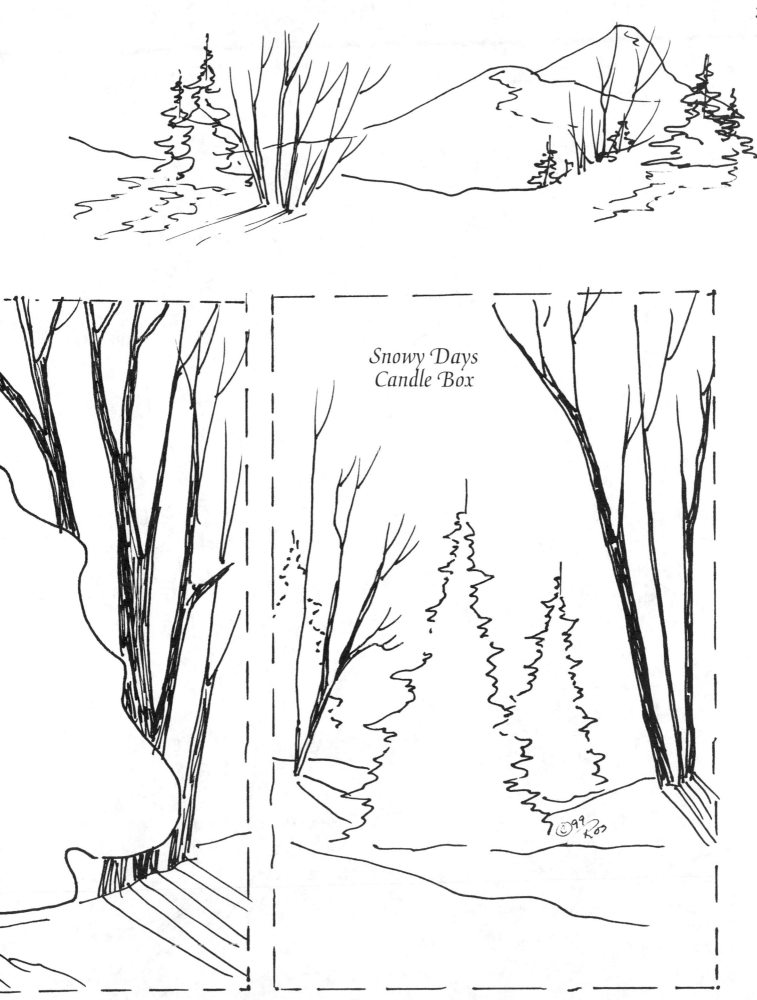

Snowy Days
Candle Box

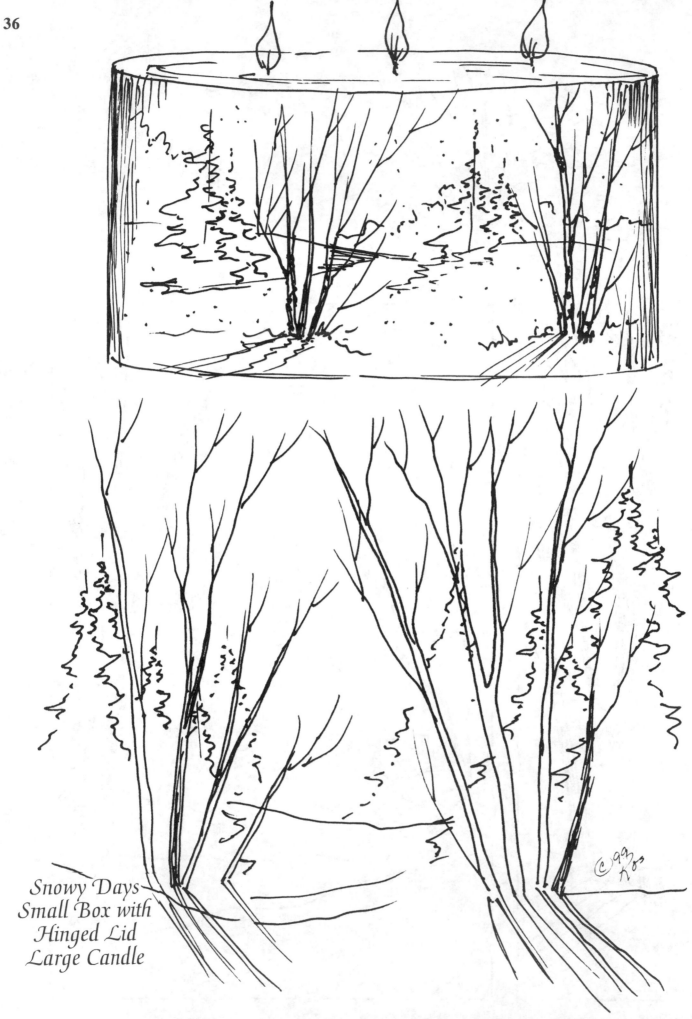

Snowy Days
Small Box with
Hinged Lid
Large Candle

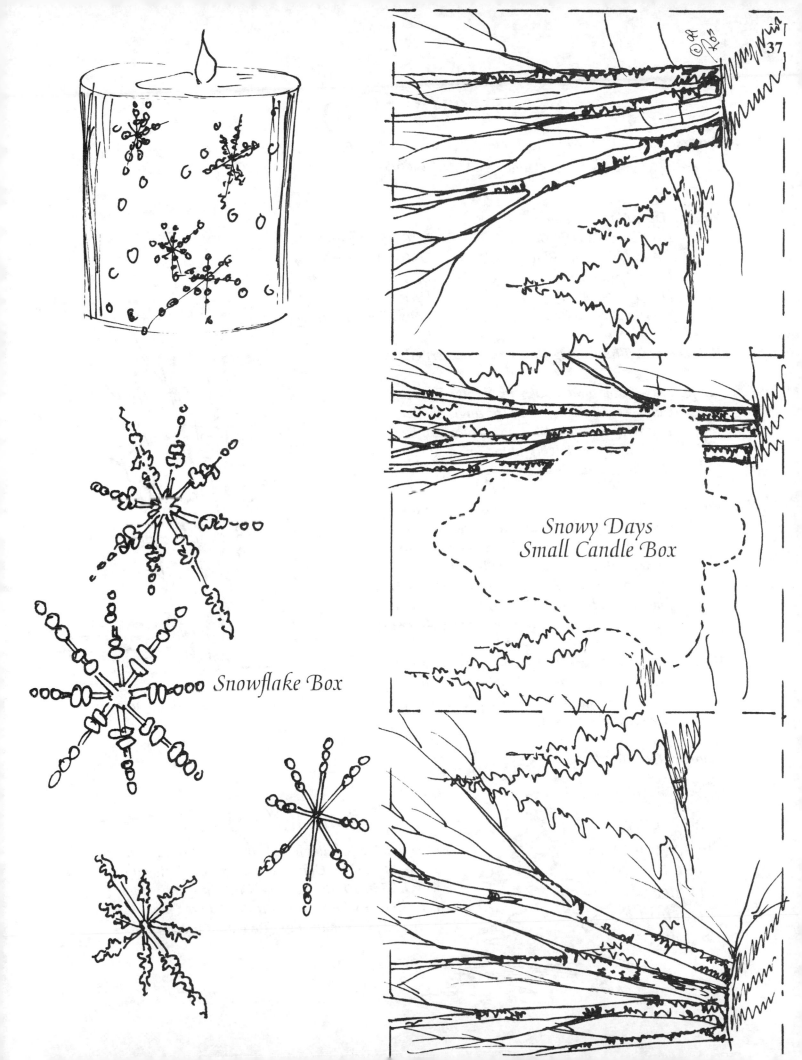

Snowflake Box

*Snowy Days
Small Candle Box*

Snowy Days

Surfaces: *Candle Boxes (Steph's Folk Art Studio – Stan Brown's Arts and Crafts) Large & Small Candles, Small Box with hinged lid (97-01366 Stan Brown's Arts and Crafts) Small Bell, Photo Album*

Paints: **DecoArt Americana**

DA024 Hi-Lite Flesh

DA039 Victorian Blue

DA068 Slate Grey

DA167 Paynes Grey

DA193 Blue Chiffon

DA031 Baby Pink

DA040 Williamsburg Blue

DA157 Black Green

DA190 Winter Blue

Faux Glazing Medium

Basecoats: **Williamsburg Blue** *and* **Faux Art Glaze**

Land Areas: *Paint land areas with* **Winter Blue** *and* **Faux Art Glaze** *using a 1/2" angle shader. The* **Williamsburg Blue** *base color will be the shadow areas. Highlight foreground with* **Hi-Lite Flesh.**

Fir Trees: *Paint fir trees with* **Williamsburg Blue**, **Black Green** *and* **Faux Art Glaze** *using a 2/0 fan brush. Adjust color to create lighter and darker values to give the feeling of distance. Tap snow on the trees with* **Winter Blue** *across some of the branches. Highlight snow on the left side of the* **Winter Blue** *snow, with* **Hi-Lite Flesh.**

Bare Trees: *Paint trees with* **Paynes Grey** *and* **Faux Art Glaze** *using a liner brush. Paint snow on the branches with* **Hi-Lite Flesh** *and* **Winter Blue.** *Paint tree shadows with* **Paynes Grey** *and* **Faux Art Glaze.**

Spatter: **Hi-Lite Flesh.**

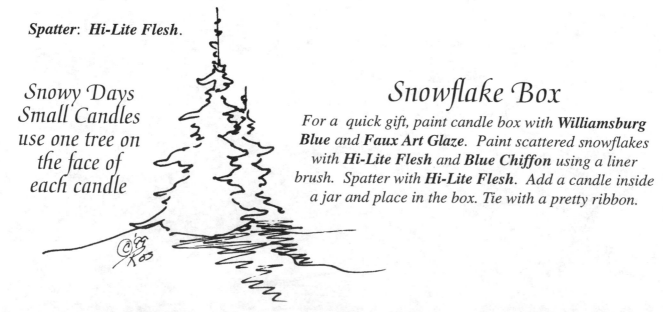

Snowy Days Small Candles use one tree on the face of each candle

Snowflake Box

For a quick gift, paint candle box with **Williamsburg Blue** *and* **Faux Art Glaze.** *Paint scattered snowflakes with* **Hi-Lite Flesh** *and* **Blue Chiffon** *using a liner brush. Spatter with* **Hi-Lite Flesh.** *Add a candle inside a jar and place in the box. Tie with a pretty ribbon.*

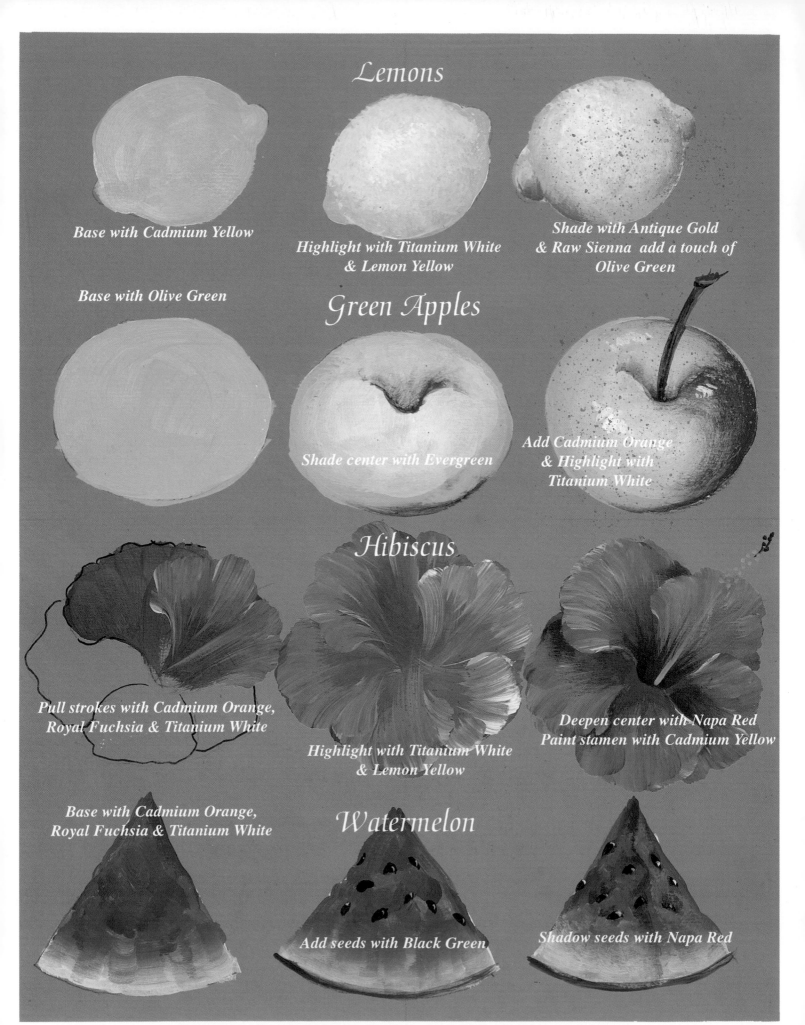

Lemons

Base with Cadmium Yellow

Highlight with Titanium White & Lemon Yellow

Shade with Antique Gold & Raw Sienna add a touch of Olive Green

Green Apples

Base with Olive Green

Shade center with Evergreen

Add Cadmium Orange & Highlight with Titanium White

Hibiscus

Pull strokes with Cadmium Orange, Royal Fuchsia & Titanium White

Highlight with Titanium White & Lemon Yellow

Deepen center with Napa Red Paint stamen with Cadmium Yellow

Watermelon

Base with Cadmium Orange, Royal Fuchsia & Titanium White

Add seeds with Black Green

Shadow seeds with Napa Red

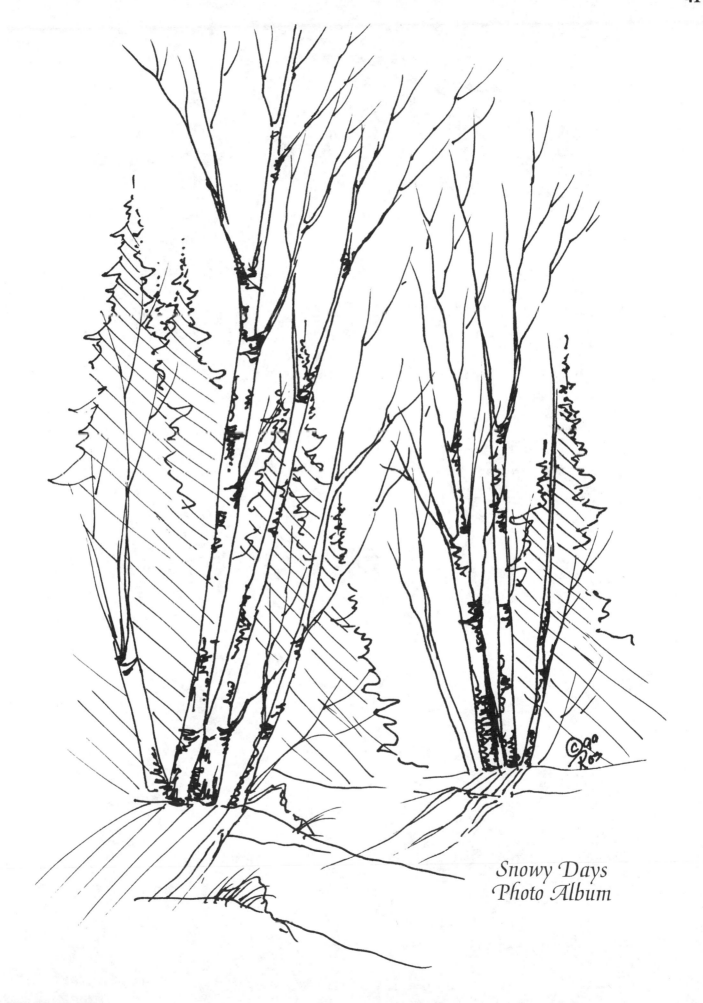

*Snowy Days
Photo Album*

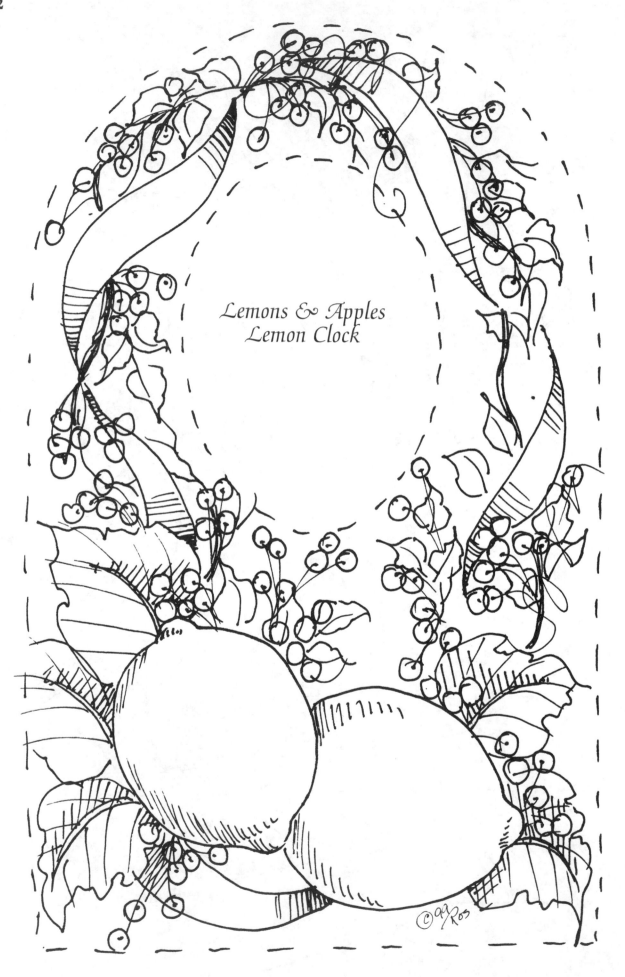

Lemons & Apples
Lemon Clock

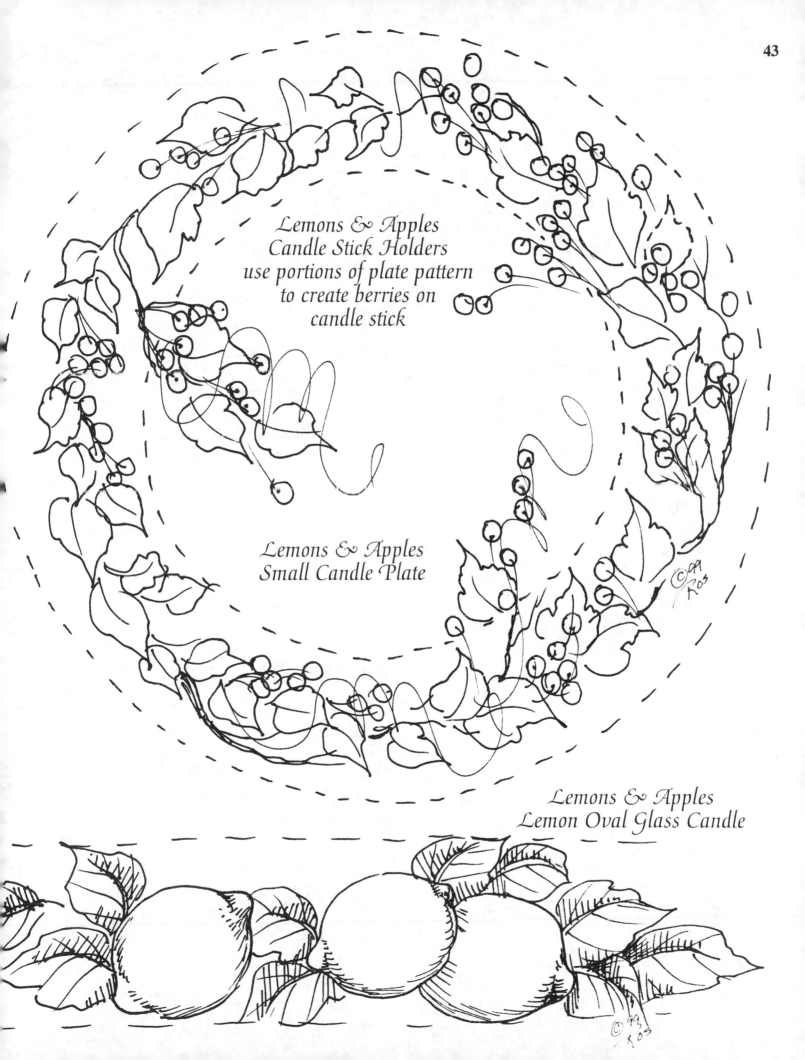

Lemons & Apples
Candle Stick Holders
use portions of plate pattern
to create berries on
candle stick

Lemons & Apples
Small Candle Plate

Lemons & Apples
Lemon Oval Glass Candle

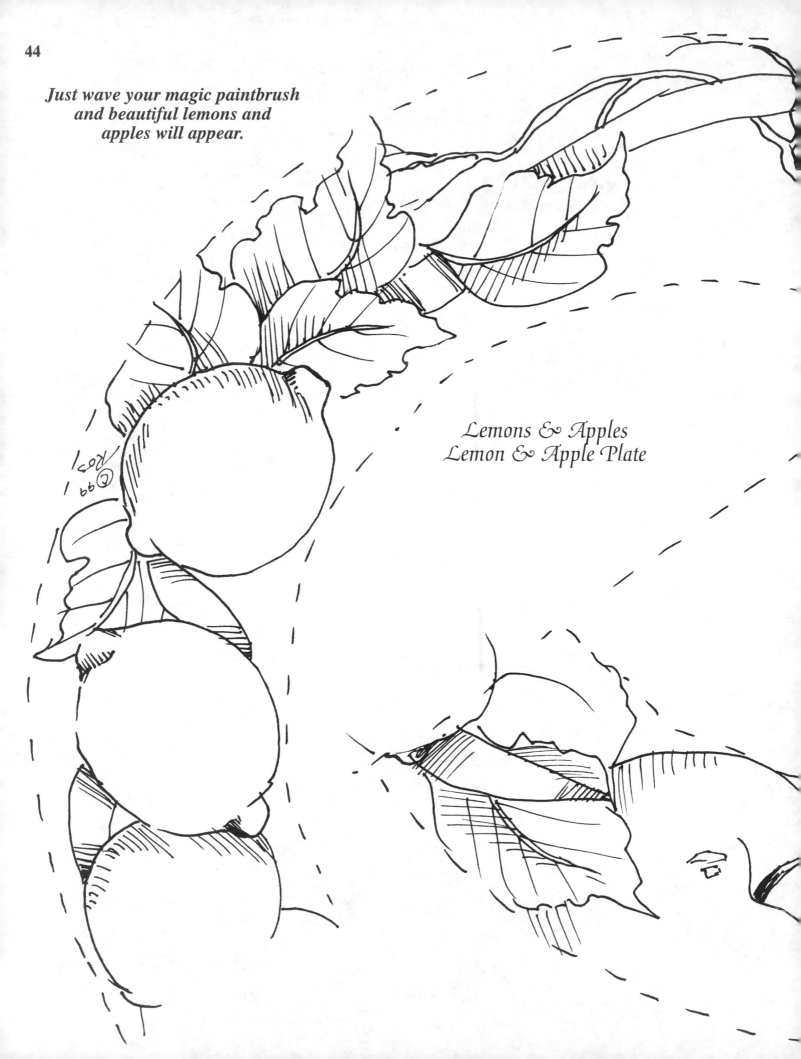

44

Just wave your magic paintbrush and beautiful lemons and apples will appear.

Lemons & Apples
Lemon & Apple Plate

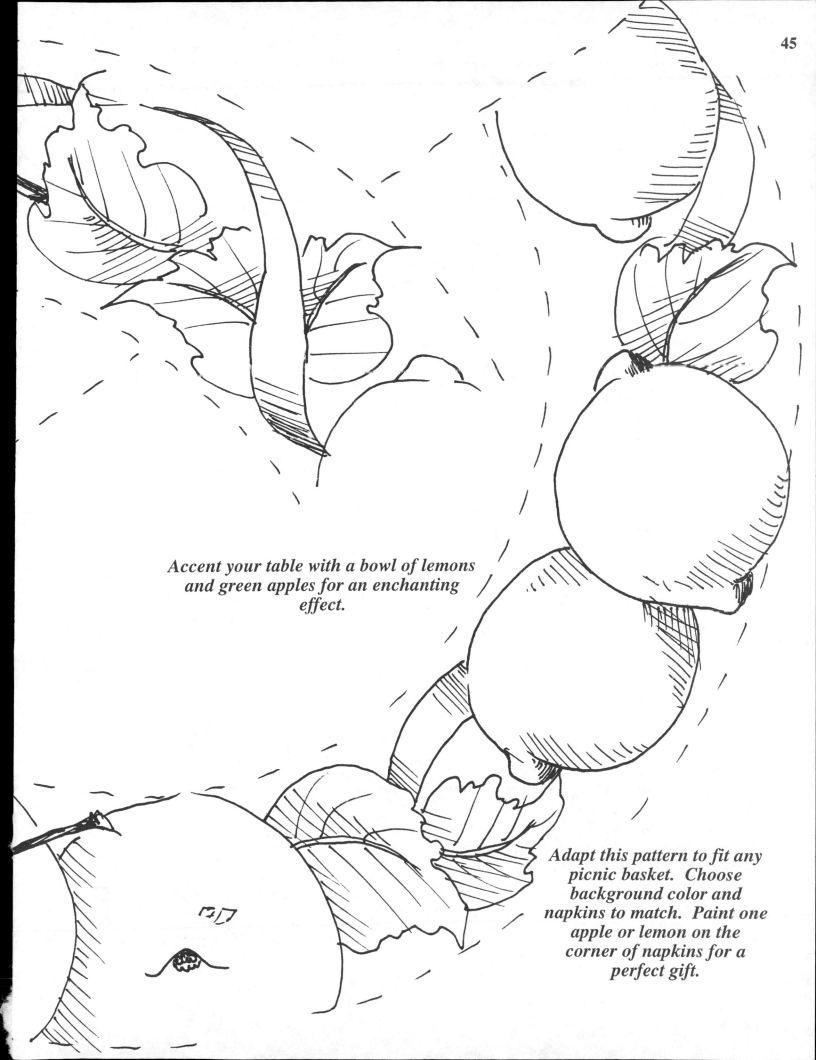

Accent your table with a bowl of lemons and green apples for an enchanting effect.

Adapt this pattern to fit any picnic basket. Choose background color and napkins to match. Paint one apple or lemon on the corner of napkins for a perfect gift.

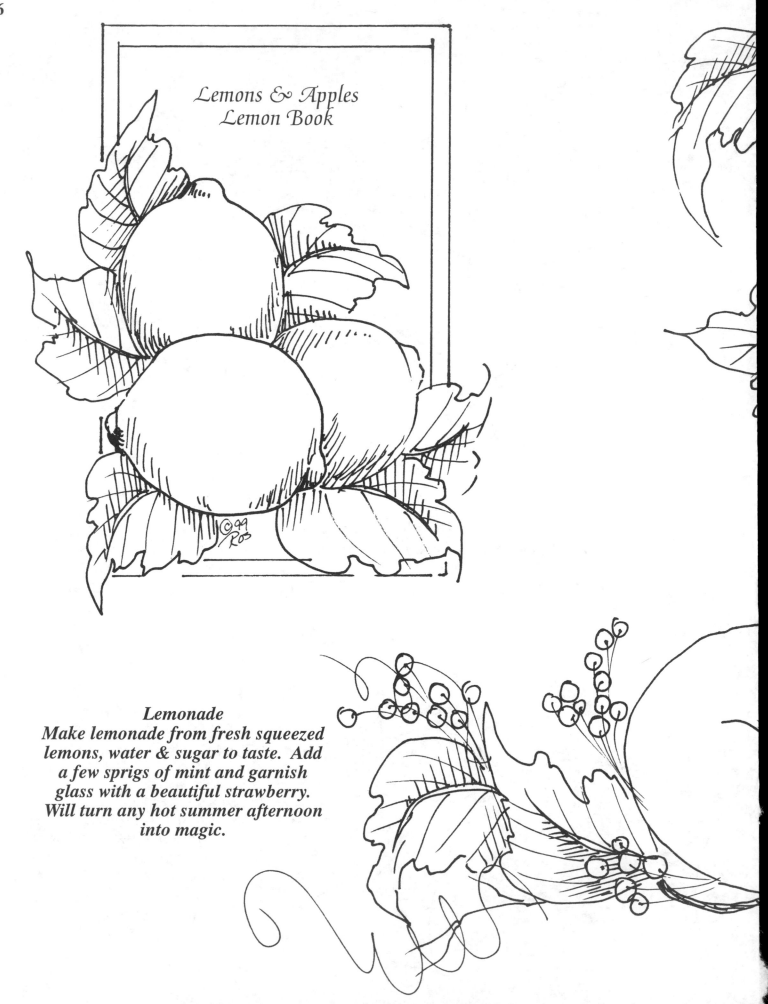

Lemons & Apples
Lemon Book

Lemonade
*Make lemonade from fresh squeezed
lemons, water & sugar to taste. Add
a few sprigs of mint and garnish
glass with a beautiful strawberry.
Will turn any hot summer afternoon
into magic.*

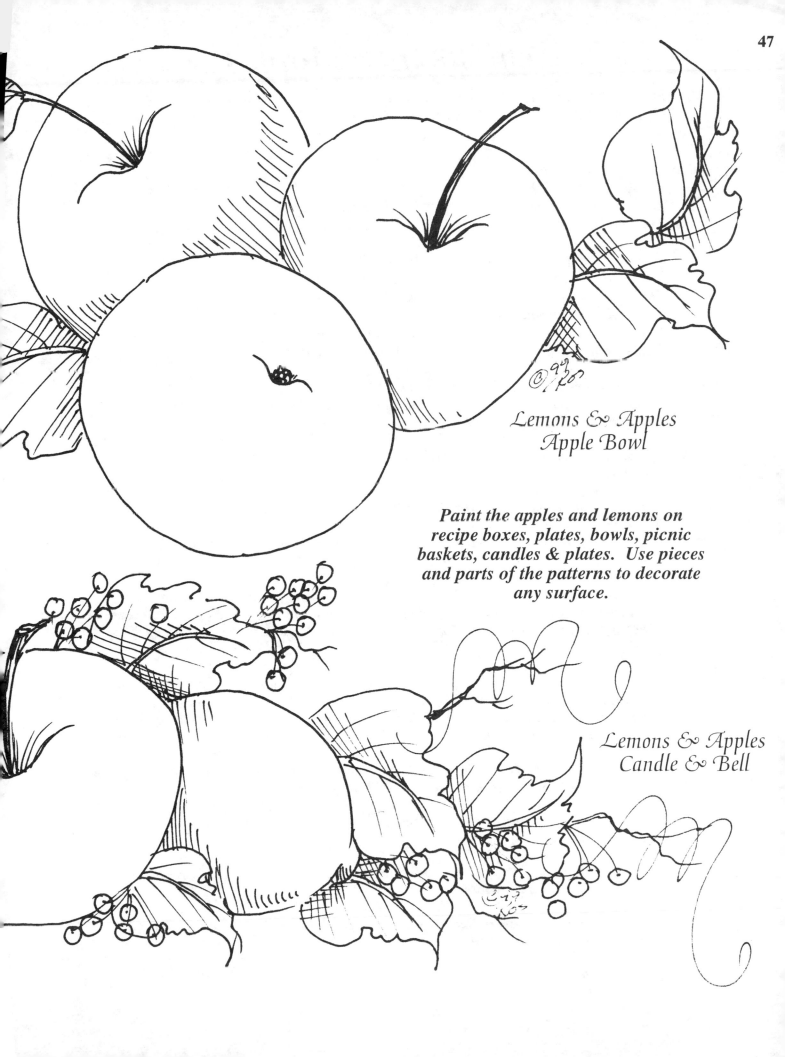

Lemons & Apples
Apple Bowl

Paint the apples and lemons on recipe boxes, plates, bowls, picnic baskets, candles & plates. Use pieces and parts of the patterns to decorate any surface.

Lemons & Apples
Candle & Bell

Lemons and Apples

Surfaces: *Candle, Large wooden Plate (Steph's Folk Art Studio) Wooden Bowl, Old Book, Oval Apple Basket (Pesky Bear) Clock (Allen Wood Crafts), Oval Candle, Small Wooden Plate, Candle Stick Holders*

Paints: **DecoArt Americana**

DA001 Titanium White	*DA009 Antique Gold*
DA010 Cadmium Yellow	*DA011 Lemon Yellow*
DA014 Cadmium Orange	*DA019 Berry Red*
DA052 Avocado	*DA056 Olive Green*
DA064 Burnt Umber	*DA068 Slate Grey*
DA082 Evergreen	*DA093 Raw Sienna*
DA101 Dioxazine Purple	*DA141 Blue Violet*
DA148 Emperor Gold	*DA157 Black Green*
DA165 Napa Red	*DA178 Blue Mist*
DA213 Admiral Blue	*Faux Glazing Medium*

Basecoats: *Oval Bowl, Basket Lid -* **Black Green**
Clock, Rim of Large Plate, Small Plate - **Admiral Blue**
Old Book - **Slate Grey**

Pattern: *Trace and transfer pattern as needed of leaves, fruit and ribbons with white or gray graphite.*

Green Apples: *Undercoat with* **Titanium White**. *Base with* **Olive Green**, *highlight with* **Titanium White** *and* **Lemon Yellow**. *Shade with* **Evergreen** *and* **Blue Mist**. *Accent with* **Cadmium Orange**. *Stem:* **Burnt Umber** *and* **Titanium White**. *Spatter with* **Emperor's Gold**.

Red Apples: *Undercoat with* **Titanium White**. *Base with* **Cadmium Orange**, *highlight with* **Titanium White** *and* **Cadmium Orange**. *Shade with* **Berry Red** *and* **Napa Red**. *Accent with* **Olive Green**. *Stem:* **Burnt Umber** *and* **Titanium White**. *Spatter with* **Emperor's Gold**.

Lemons: *Undercoat with* **Titanium White**. *Base with* **Cadmium Yellow**. *Tap highlights with* **Titanium White** *and* **Lemon Yellow** *using foliage brush. Use lots of paint to add texture. Let dry and glaze with* **Antique Gold**, **Raw Sienna** *and* **Olive Green**. *Branches:* **Burnt Umber** *and* **Emperor's Gold**.

Leaves: *Base with* **Avocado**. *Highlight with* **Olive Green** *and* **Blue Mist**. *Shade with* **Evergreen**. *Paint veins with* **Olive Green** *and a touch of* **Titanium White**.

Berries: *Q-tip berries with* **Faux Art Glaze**, **Blue Mist**, **Dioxazine Purple**, **Olive Green**, *and* **Titanium White**.

Ribbons: *Paint ribbons with* **Olive Green** *and* **Faux Art Glaze**. *Shade with* **Evergreen** *and highlight with* **Titanium White**.

Ribbon on basket: *Base with* **Berry Red**. *Highlight with* **Cadmium Orange** *and* **Titanium White**. *Shade with* **Napa Red**.

Spatter: *Emperor's Gold*

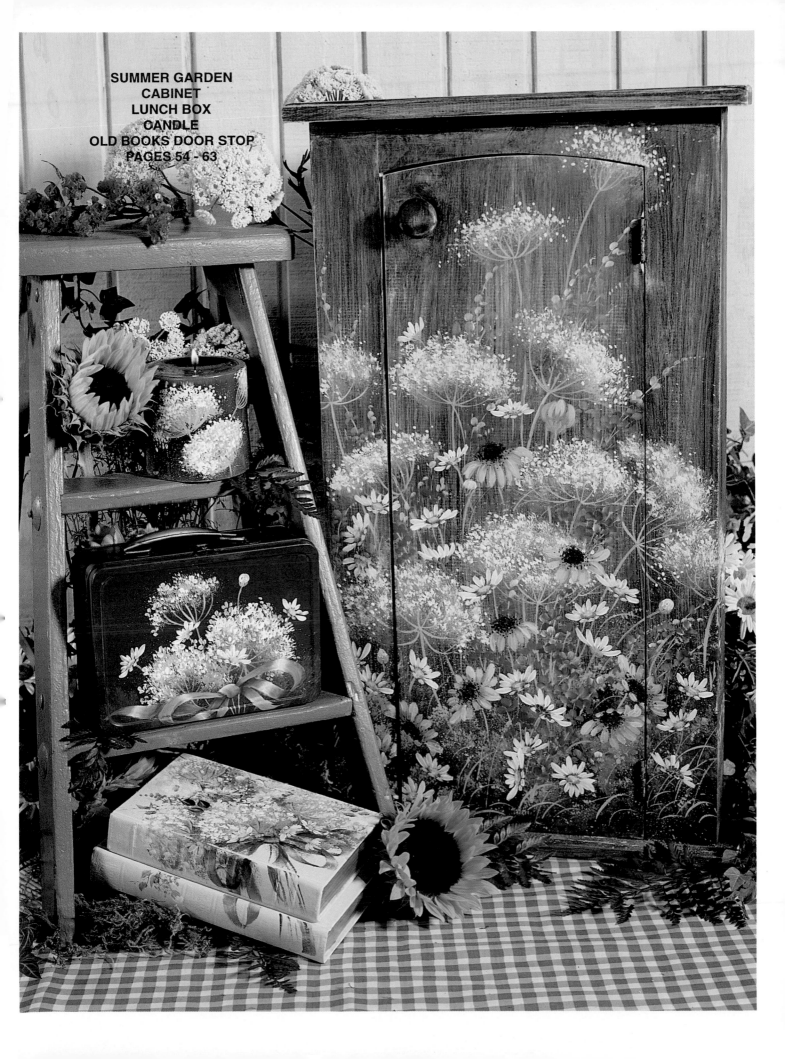

SUMMER GARDEN
CABINET
LUNCH BOX
CANDLE
OLD BOOKS DOOR STOP
PAGES 54 - 63

Queen Anne's Lace

Tap with 3/4" Foliage Brush using
Olive Green & Blue Mist

Highlight with Lemon Yellow

Add a tap of White

Add dots to create
flower petals

Spatter with White

Paint stems with
Olive Green & Lemon Yellow

Black Eyed Susans

Daisies

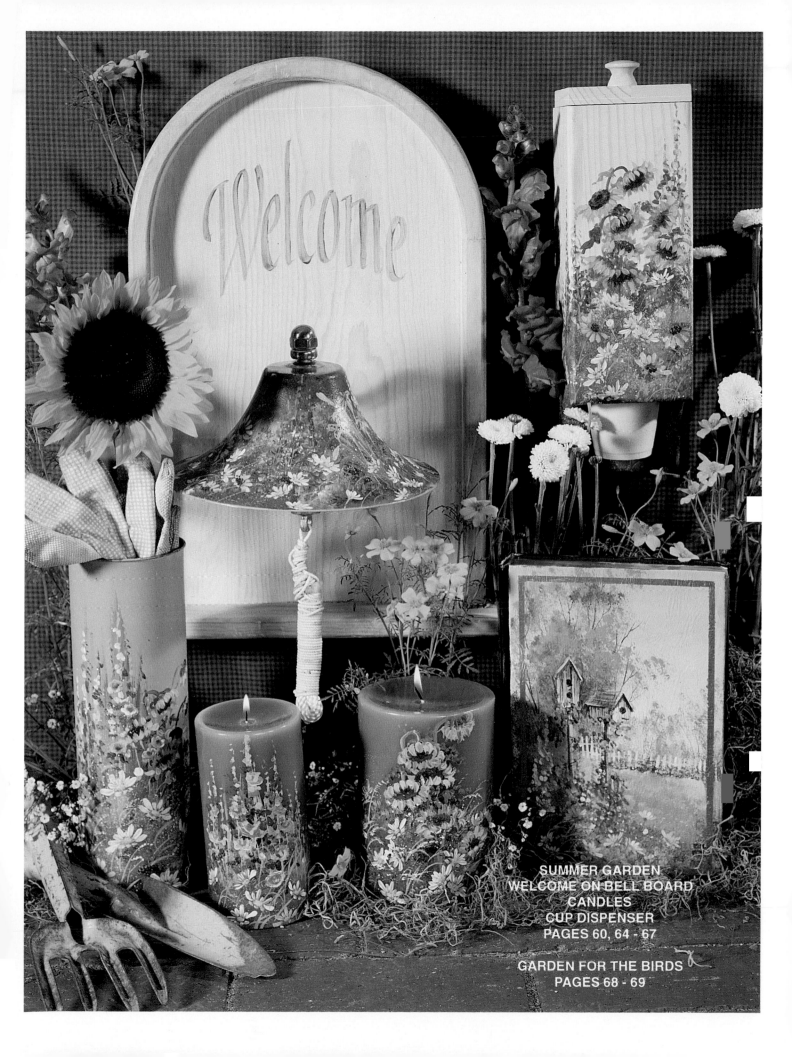

SUMMER GARDEN
WELCOME ON BELL BOARD
CANDLES
CUP DISPENSER
PAGES 60, 64 - 67

GARDEN FOR THE BIRDS
PAGES 68 - 69

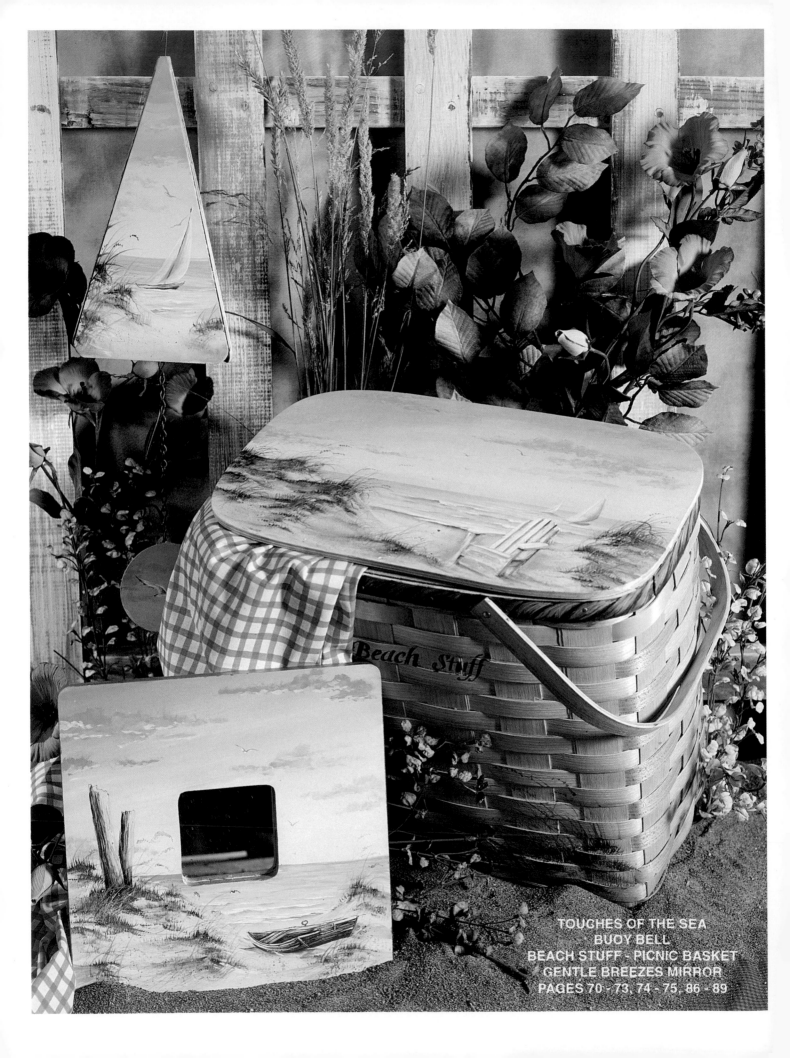

TOUCHES OF THE SEA
BUOY BELL
BEACH STUFF - PICNIC BASKET
GENTLE BREEZES MIRROR
PAGES 70 - 73, 74 - 75, 86 - 89

Lemons & Apples
Apple Basket

Apples

Beautiful juicy apples and a huge glass of lemonade make a perfect afternoon snack. Fill a bowl or basket and bring out the pitcher for all to share.

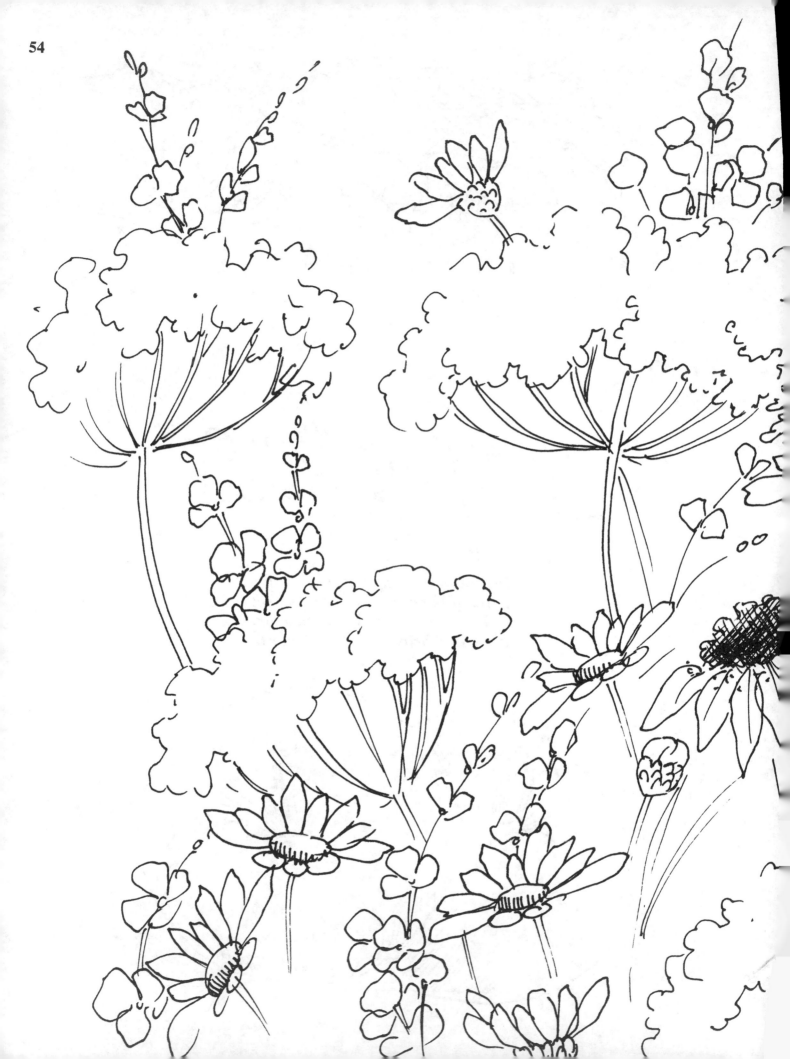

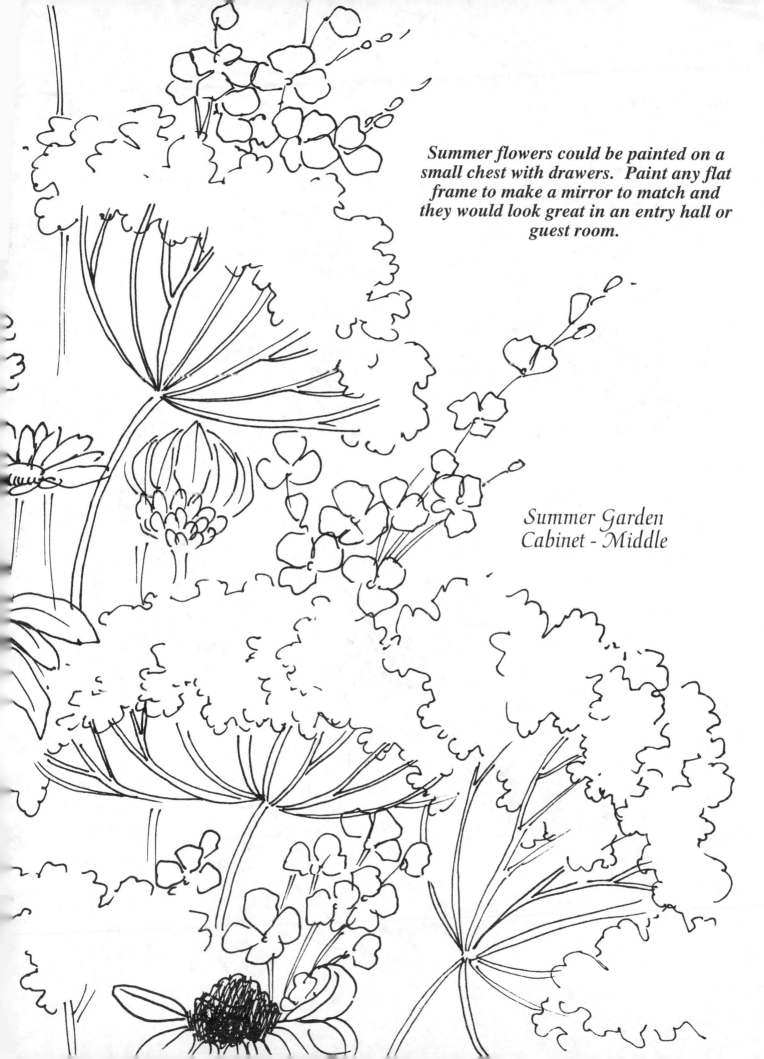

Summer flowers could be painted on a small chest with drawers. Paint any flat frame to make a mirror to match and they would look great in an entry hall or guest room.

*Summer Garden
Cabinet - Middle*

Summer Garden
Cabinet - Bottom

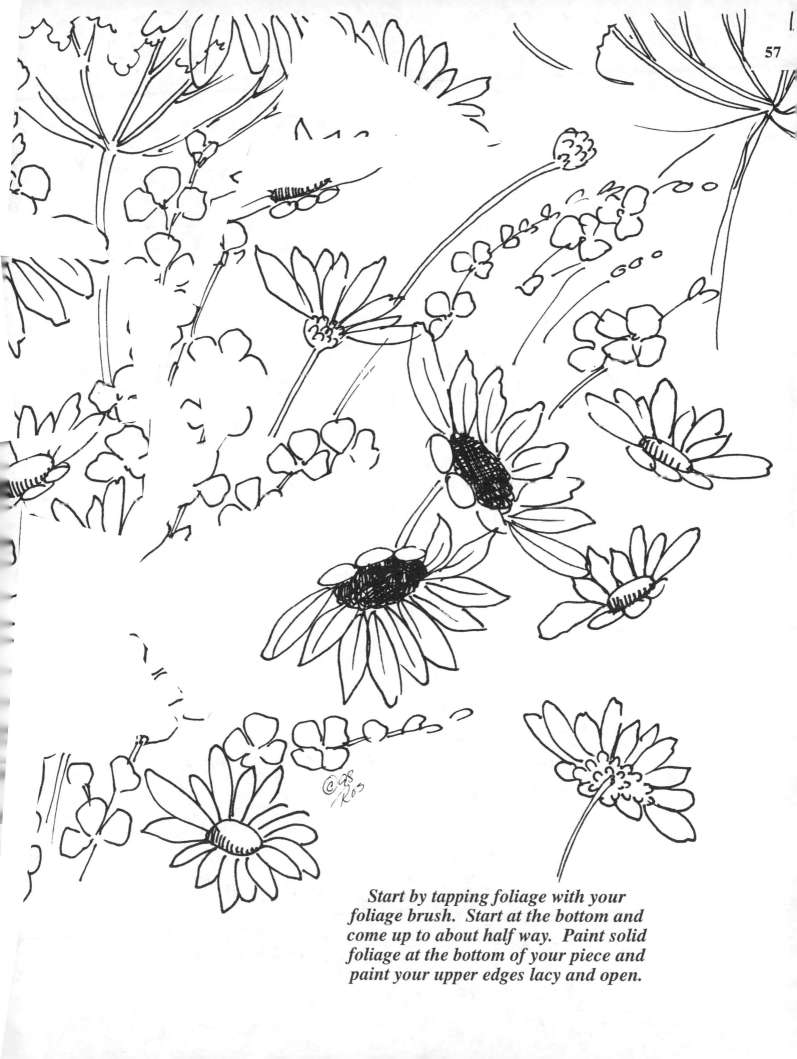

Start by tapping foliage with your foliage brush. Start at the bottom and come up to about half way. Paint solid foliage at the bottom of your piece and paint your upper edges lacy and open.

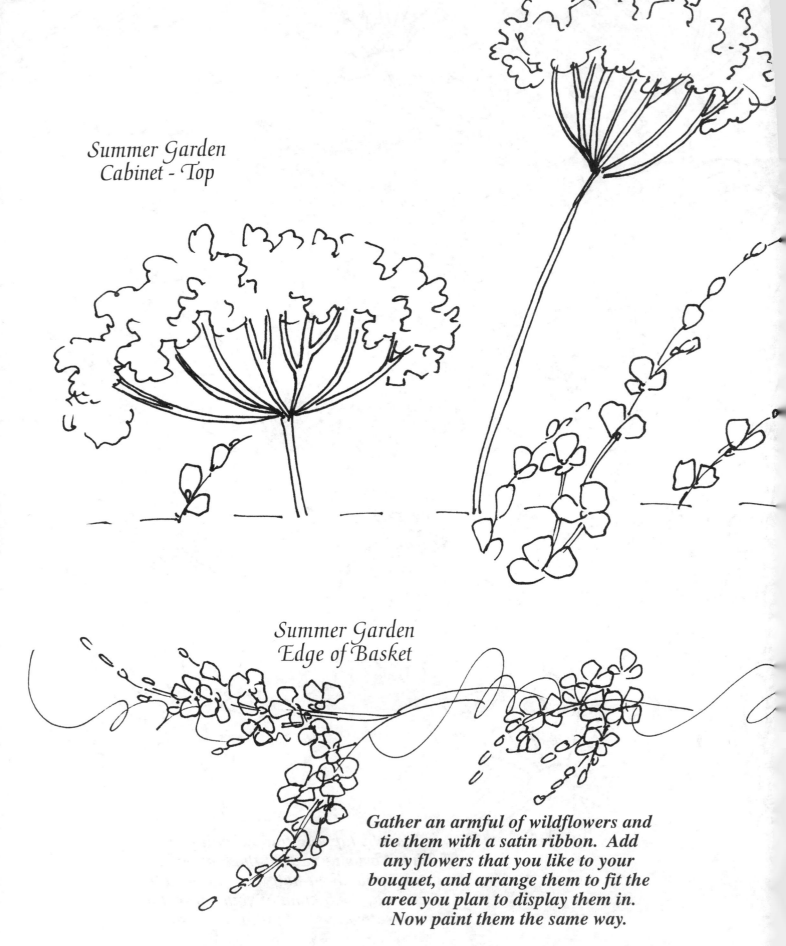

*Summer Garden
Cabinet - Top*

*Summer Garden
Edge of Basket*

**Gather an armful of wildflowers and
tie them with a satin ribbon. Add
any flowers that you like to your
bouquet, and arrange them to fit the
area you plan to display them in.
Now paint them the same way.**

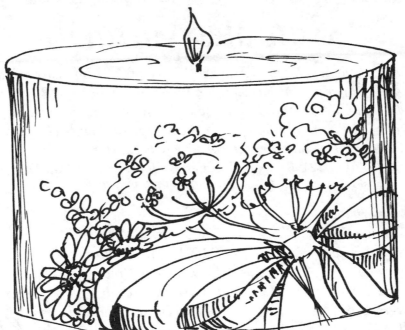

Paint your favorite designs on a candle for a perfect hostess or thank you gift. Great little present for a teacher too.

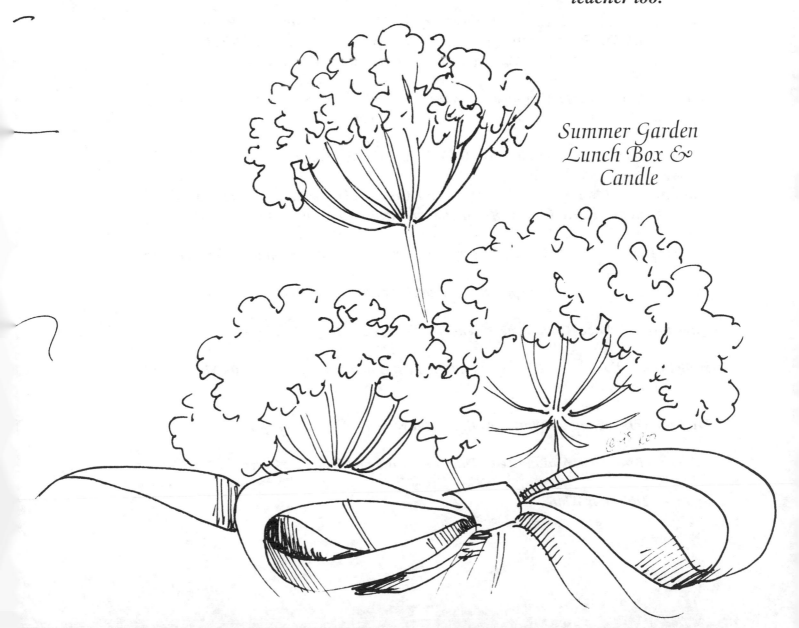

Summer Garden
Lunch Box &
Candle

Summer Garden

Surfaces: *Corner Cabinet (Taylor's Arts and Crafts, 800 Carbon City Rd. Morganton, NC 28655 828-584-4771), Small Paint Basket (Stan Brown/Pesky Bear), "Post " Box (Cutting Edge PO. Box 3000 Chino, CA 91708), Birdhouse w/ Tin Roof (Country Pleasures, HCR Box 53 Thayer, Missouri 65791 Phone 417-264-7246), Stove Pipe Birdhouse (Hardware Store), Candlestick (Painting Cottage), Tin container (Decorative Arts Learning Center 6070 Indian River Rd, Va. Beach, VA 757-420-0042), Brass Bell, Candles, Books, Paper Cup Dispenser, Antique Tin Lunch Box, Brush Holder*

Paints: **DecoArt Americana**

DA001 Titanium White	*DA009 Antique Gold*
DA010 Cadmium Yellow	*DA011 Lemon Yellow*
DA052 Avocado	*DA056 Olive Green*
DA063 Burnt Sienna	*DA064 Burnt Umber*
DA082 Evergreen	*DA101 Dioxazine Purple*
DA141 Blue Violet	*DA157 Black Green*
DA158 Antique Teal	*DA167 Paynes Grey*
DA178 Blue Mist	
Faux Glazing Medium	

Basecoat: *Corner Cabinet and Porch Mirror-* **JW White Lightning** *with* **Black Green** *and* **Faux Art Glaze** *on top. "Post" box - Bird House, Candle stick -* **Black Green**, *Cup Dispenser -* **White Lightning**, *Small project basket and Tin Canister -* **Blue Mist**.

Note: *Instructions and diagrams are in the front of the book and color worksheets are scattered throughout. Colors are listed here for reference.*

Foliage: *Avocado, Evergreen, Olive Green, and Faux Art Glaze.*

Sunflowers and Black Eyed Susans: *Antique Gold, Cadmium Yellow, Lemon Yellow.* *Centers*: *Burnt Umber, Burnt Sienna, Paynes Grey, and Emperor's Gold*

Daisies: *Titanium White. Centers - Cadmium Yellow shaded with Cadmium Yellow and Burnt Sienna.*

Delphiniums: *Dioxazine Purple, Blue Violet, Titanium White and Olive Green.*

Queen Anne's Lace: *Olive Green, Lemon Yellow, Blue Mist and Titanium White.*

Hollyhocks: *Evergreen, Olive Green, Blue Mist, Faux Art Glaze, Antique Mauve and Titanium White.*

Wild Flowers: *Titanium White, Antique Mauve and Dioxazine Purple.*

Ribbon: *Blue Mist, Antique Teal, Titanium White and Faux Art Glaze.*

Spatter: *Titanium White*

Sand Dunes

Gentle Breezes

Surf & Sand

a Oats

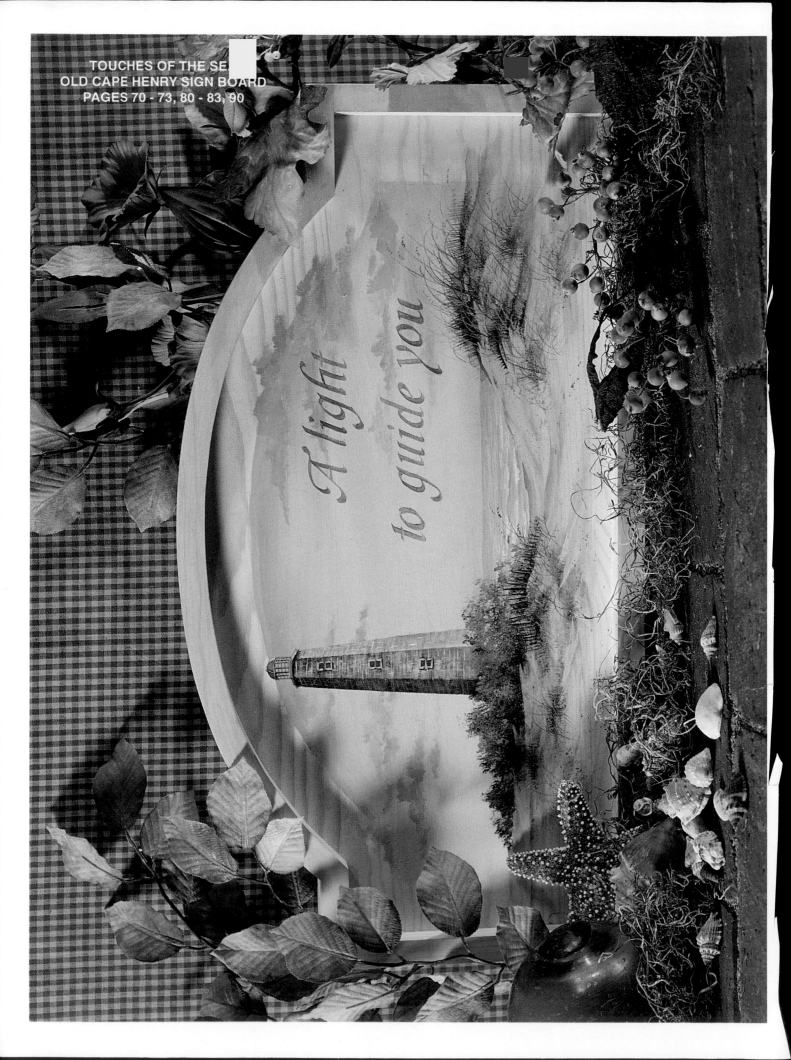

A light
to guide you

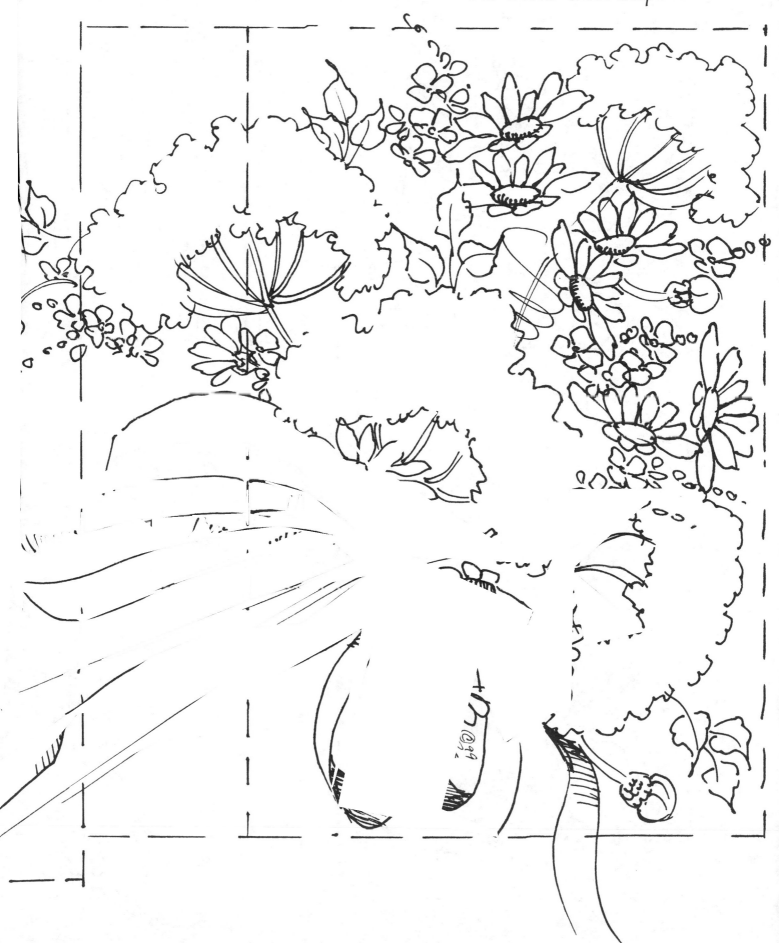

64

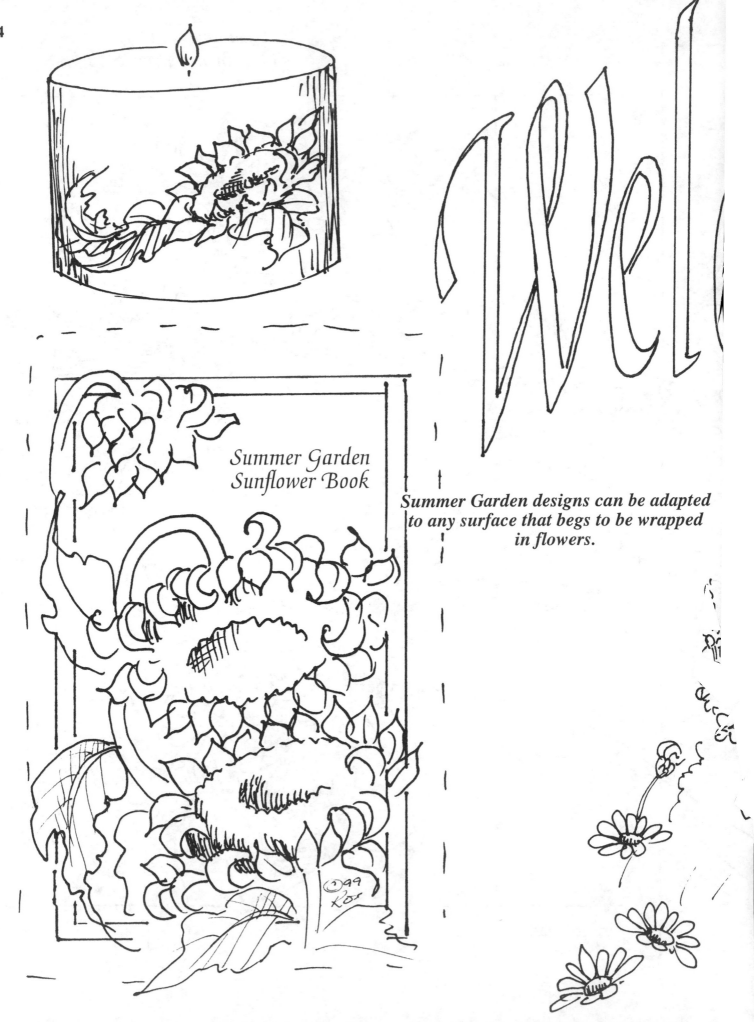

*Summer Garden
Sunflower Book*

Summer Garden designs can be adapted to any surface that begs to be wrapped in flowers.

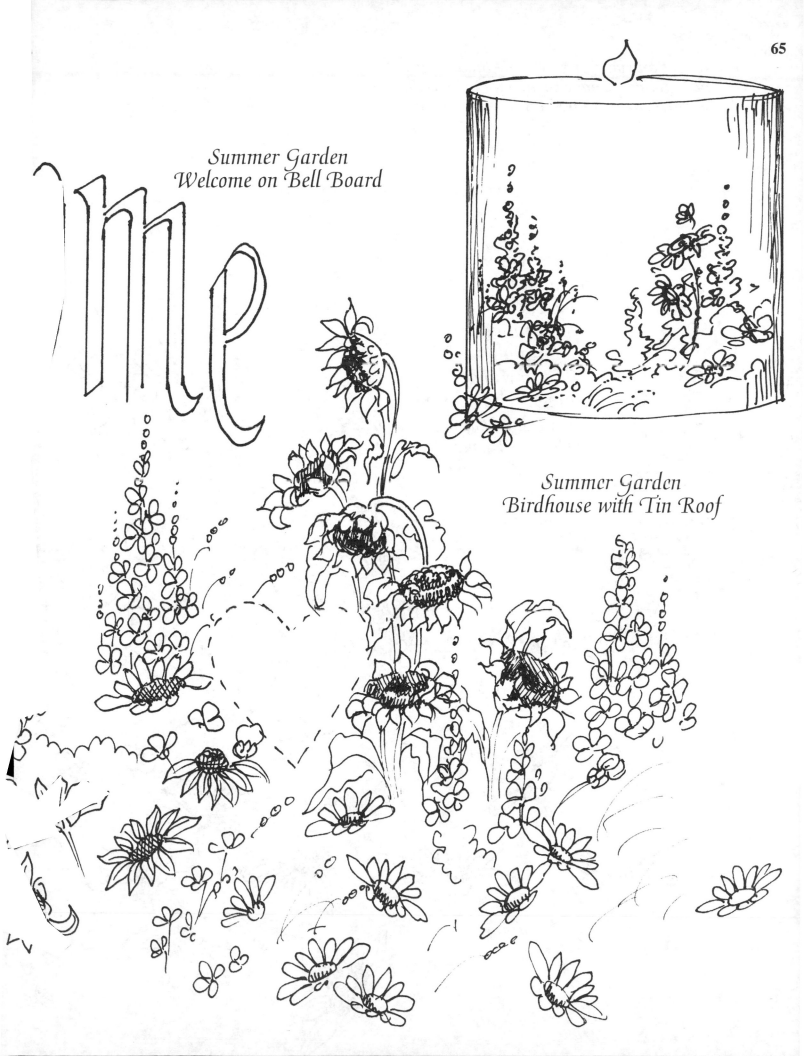

*Summer Garden
Welcome on Bell Board*

*Summer Garden
Birdhouse with Tin Roof*

Paint on some of your old candles that have faded. I have turned an old candle upside-down painted on it and created a plate to match. They look great sitting in the bathroom.

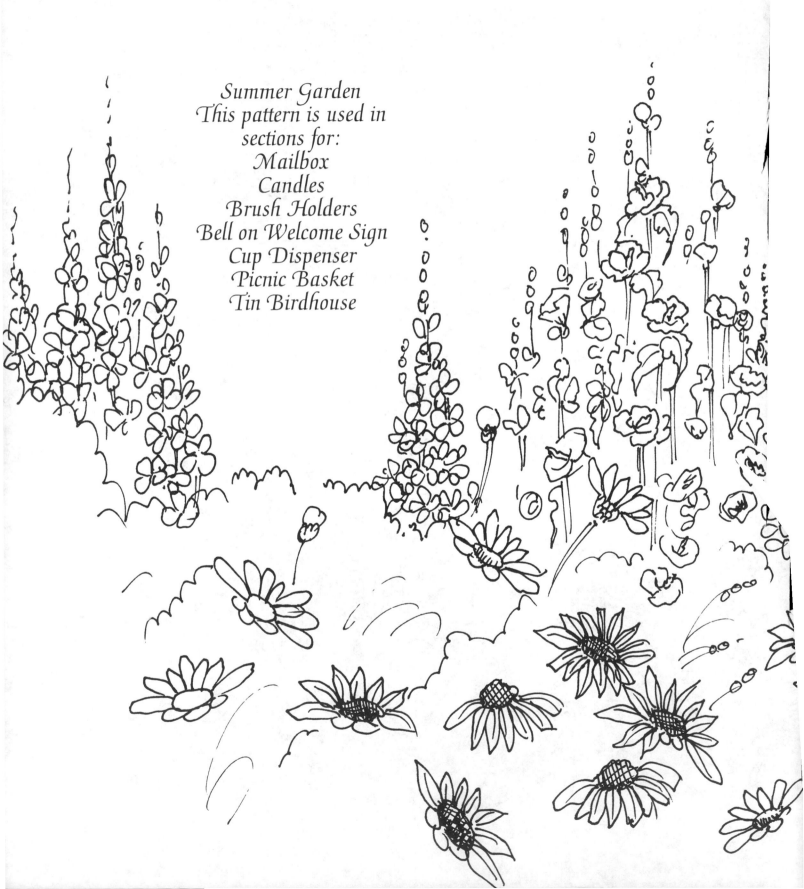

Summer Garden
This pattern is used in
sections for:
Mailbox
Candles
Brush Holders
Bell on Welcome Sign
Cup Dispenser
Picnic Basket
Tin Birdhouse

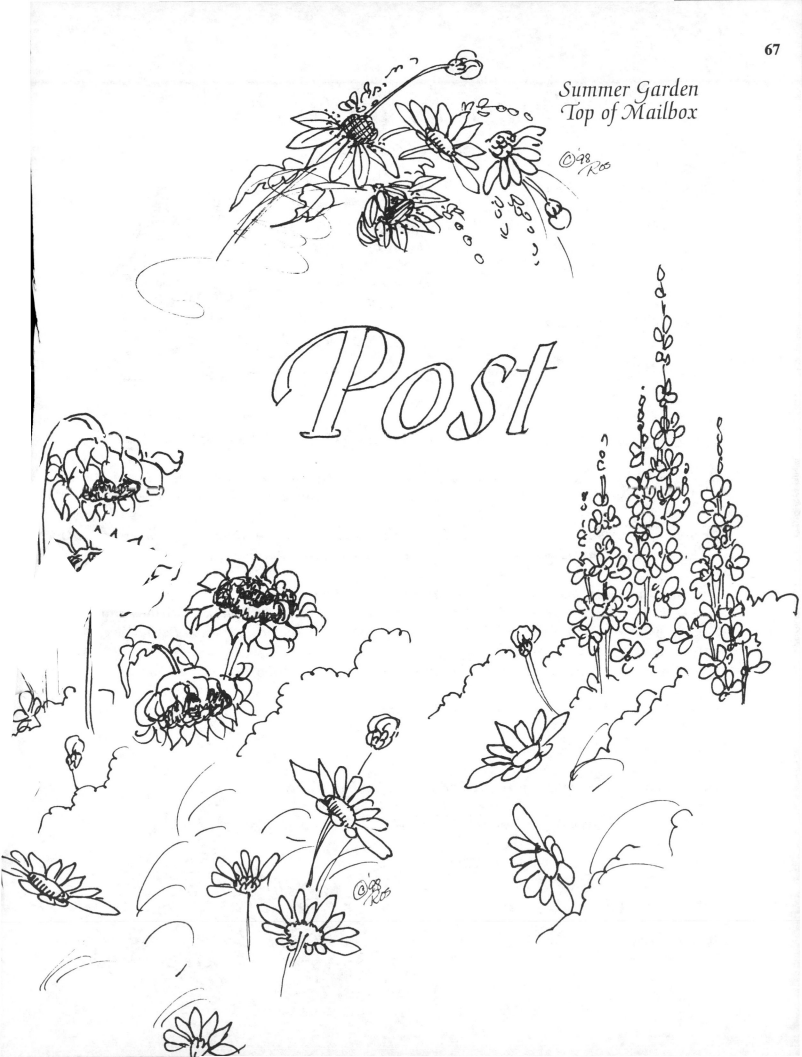

Summer Garden
Top of Mailbox

Garden for the Birds

Surface: Old Book

Paints: **DecoArt Americana Acrylics**

DA001 Titanium White DA010 Cadmium Yellow
DA052 Avocado DA056 Olive Green
DA063 Burnt Sienna DA064 Burnt Umber
DA068 Slate Grey DA082 Evergreen
DA101 Dioxazine Purple DA141 Blue Violet
DA148 Emperor's Gold DA157 Black Green
DA162 Antique Teal DA167 Paynes Grey
DA178 Blue Mist DA190 Winter Blue
DA193 Blue Chiffon

Basecoat: **Black Green**

Sky: *Paint sky starting at the horizon line with* **Hi-Lite Flesh**, **Blue Chiffon** *and* **Winter Blue**.

Background Trees: *Tap background trees with* **Evergreen**, **Avocado**, **Olive Green**, *and* **Blue Mist**, *using the 3/4" foliage brush. Paint trunks with* **Burnt Umber** *and* **Hi-Lite Flesh**.

Ground Area: *Paint distant ground with* **Hi-Lite Flesh** *and* **Olive Green**, **Blue Mist**. *Tap bushes in the foreground with* **Avocado**, **Evergreen**, **Olive Green** *and* **Blue Mist**.

Pattern: *Trace and transfer birdhouse with gray graphite. Paint birdhouses with* **Burnt Umber** *on the left shadow sides and* **Slate Grey** *on the light sides. Streak dark sides with* **Winter Blue** *and highlight sunny side with* **Hi-Lite Flesh**. *Detail with* **Burnt Umber** *and* **Paynes Grey**

Rose Vines: *Tap leaves with* **Avocado**, **Evergreen** *and* **Olive Green** *using the tip of #2 round.*

Roses: *Tap roses with* **Antique Mauve** *and* **Titanium White**.

Fence: **Titanium White**

Delphiniums: **Blue Violet**, **Dioxazine Purple** *and* **Titanium White**.

Daisies: **Titanium White**. **Centers** - **Cadmium Yellow** *and* **Burnt Sienna**.

Filler Flowers: **Antique Mauve** *and* **Titanium White**.

Spatter: **Titanium White**

Boarder: **Emperor's Gold**

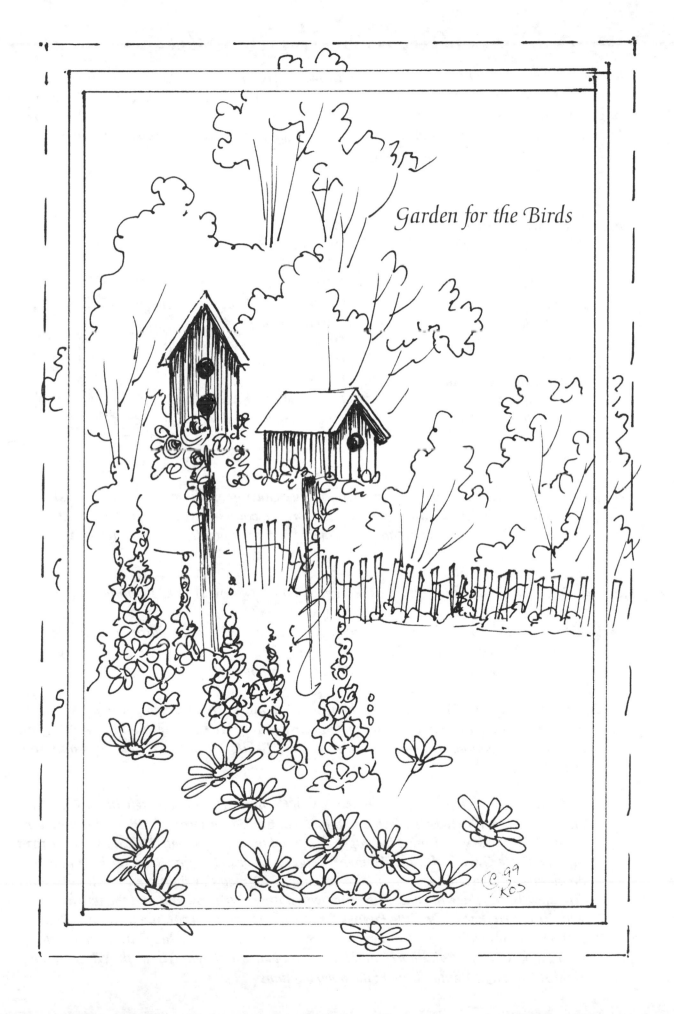

Garden for the Birds

Touches of the Sea

Surfaces: Cape Henry Welcome Sign (Stan Brown's Arts and Crafts, Ros' Wood/ DALC Woodworking) Gentle Breezes Board, Summer Welcome and Mirror (Ros's Wood/ DALC Woodworking) Cape Henry Signboard (medium goosecreek board Stan Brown's Arts and Crafts) Cape Hatteras Lighthouse (medium routed oval and magazine holder (Stan Brown's Arts and Crafts), Buoy Bell, Beach Stuff - Tall Basket

Paints: **DecoArt Americana**

DA001 Titanium White	DA014 Cadmium Orange
DA019 Berry Red	DA024 Hi-Lite Flesh
DA052 Avocado	DA056 Olive Green
DA063 Burnt Sienna	DA064 Burnt Umber
DA068 Slate Grey	DA067 Lamp Black
DA079 Brandy Wine	DA081 Colonial Green
DA082 Evergreen	DA093 Raw Sienna
DA148 Emperor Gold	DA167 Paynes Grey
DA178 Blue Mist	DA190 Winter Blue
DA193 Blue Chiffon	Faux Glazing Medium

Basecoat: **JW White Lightning**

Sky: Starting in the middle, touch your brush into **Faux Glazing Medium** and **Hi-Lite Flesh**, paint across the sky. Pick up **Blue Chiffon**, blending the colors as you go. Pick up **Winter Blue** at the top. Clean your brush and paint the bottom section with **Hi-Lite Flesh**. Allow to dry.

Pattern: Trace as much of the pattern as you need and transfer with gray graphite.

Sunrise Glow: Paint across the lower sky and upper water with **Faux Art Glaze**, **Hi-Lite Flesh** and a little **Cadmium Orange**. Fade the color into the sky by picking up more **Faux Art Glaze**. It is OK to paint over pattern lines of lighthouse and dunes.

Clouds: Paint clouds with **Winter Blue** and touch of **Cadmium Orange** using a small worn brush and a circular motion. Vary the color by adding **Hi-Lite Flesh** and **Blue Chiffon**. Highlight the bottom of some of the clouds with **Hi-Lite Flesh** and a touch of **Cadmium Orange**.

Old Cape Henry: Paint the top of the lighthouse with **Colonial Green**. Shade with **Paynes Grey** and highlight with **Hi-Lite Flesh** and a touch of **Cadmium Orange**. Place masking tape carefully in the sky to protect the edges of the lighthouse. Pat with **Hi-Lite Flesh, Burnt Sienna, Slate Grey** and **Burnt Umber** to suggest bricks. Let dry. Use masking tape to create the sections. Glaze one section at a time. Lighten the right section with glaze of **Hi-Lite Flesh**. Glaze the middle section with a little **Burnt Sienna** and the left section with **Burnt Umber** and a little **Paynes Grey**. Adjust colors according to your lighthouse. Paint windows with **Paynes Grey**. Trim around windows with **Blue Chiffon** and detail with **Paynes Grey**. Paint horizontal lines to indicate brick with **Titanium White** in the right section and **Winter Blue** in the other sections.

Scheewe Publications Inc.

CHECK OUT OUR WEB SITE AT : http://www.painting-books.com

Jars Jars Jars 2
By Cindy Trombley
Acrylic - #537 Retail $10.50

Maple Sugar 9
By Roberta Hall
Acrylic - #542 Retail $10.50

Bear's Inn Jars
Paula Walsh
Acrylic - #539 Retail $10.50

Special Welcomes 7
By Corinne Miller
Acrylic - #543 Retail $10.50

Gran's Cottage
By Ros Stallcup
Acrylic - #533 Retail $12.95

How Delicious
By Elaina Appleby
Acrylic - #541 Retail $10.50

A Painters Garden 4
By Jane Dillon
Acrylic - #536 Retail $10.50

Artistic Treasures
By June Houck & Veda Parsley
Acrylic - #535 Retail $10.50

Enjoy The Seasons 2
By Roni LaBree
Acrylic - #538 Retail $10.50

Gifts & Graces 3
By Charlene Pena
Acrylic - #534 Retail $10.50

Beginning Watercolors
By Susan Scheewe Brown
Acrylic & Watercolor
#545 - Retail $12.95

SHIPPING & HANDLING CHARGES
BOOKS: Add $3.00 for the First Book, for shipping and handling.

Add $1.50 per additional book.

TAPES: Please Add $4.00 for handling & postage, PER TAPE.
Sorry we must have a "NO REFUND - NO RETURN" policy.

U.S. CURRENCY

e-mail us:
SCHEEWEPUB@aol.com

LOOK FOR US ON LINE!
http://www.painting-books.com

13435 N.E. Whitaker Way Portland, Or. 97230
PH (503)254-9100 FAX (503)252-9508
Orders Only Please (800)796-1953

Old Cape Henry Lighthouse

Masking Tape

Masking Tape

Sand Dunes
& Sea Oats

Gentle Breezes

Old Boat

Touches of the Sea continued

Cape Hatteras*:* *Paint top of the lighthouse with **Lamp Black** and highlight on the left side with **Hi-Lite Flesh** and a touch of **Cadmium Orange**. Place masking tape in the sky along the outer edges of the lighthouse. Paint main section of the lighthouse with **Titanium White**. Glaze with **Hi-Lite Flesh** and a touch of **Cadmium Orange** down the left side. Glaze **Slate Grey** down the right side. Paint stripes with **Lamp Black**. Paint the base of the lighthouse with **Burnt Sienna** and **Burnt Umber** to indicate bricks and trim with **Slate Grey** and **Paynes Grey**. Highlight on the left with **Hi-Lite Flesh** and touch of **Cadmium Orange**.*

Old Boat and Posts*:* *Paint the boat and posts with **Slate Grey**, shade with **Burnt Umber** and **Paynes Grey**. Highlight with **Hi-Lite Flesh** and a touch of **Cadmium Orange**. Paint bottom of the boat with **Berry Red** and shade with **Paynes Grey**. Paint cracks and board lines with **Paynes Grey**.*

Water*:* *Place masking tape in the sky to create a straight waterline. Start at horizon line, using the chisel edge of your brush paint streaks of **Winter Blue**, **Blue Chiffon** and **Faux Art Glaze**. Let some of the color underneath show through. Paint whitecaps and foam with **Titanium White**. Add a few streaks of **Winter Blue** under the whitecaps.*

Sand*:* *Create shapes in the sand and along the shoreline with **Hi-Lite Flesh** and a touch of **Raw Sienna** with **Faux Art Glaze**. Shadow dunes with cloud colors. Wet the surface with water and paint shadow areas on the wet surface creating a watercolor effect. The lower edges of the shadows should fade away.*

Chair*:* *Paint chair with **Slate Grey** and highlight with **Hi-Lite Flesh**.*

Grasses*:* *Wet the surface of the dune with water and flip up grasses with **Evergreen** and **Raw Sienna** using a 2/0 fan brush. Paint individual grasses with **Evergreen**, **Raw Sienna** and **Hi-Lite Flesh** using a liner brush. Tap sea oats with **Raw Sienna** using the tip of your liner.*

Highlight*:* *Paint extra highlights on the light side of the dunes with **Hi-Lite Flesh** and a touch of **Cadmium Orange**. Slide into the edge of the grass clumps with the chisel edge of your brush to set the grasses into the sand.*

Spatter*:* *Cover the sky with a paper towel and spatter sand with **Hi-Lite Flesh**, **Winter Blue**, and **Emperor's Gold**.*

Seagulls*:* *Slate Grey*

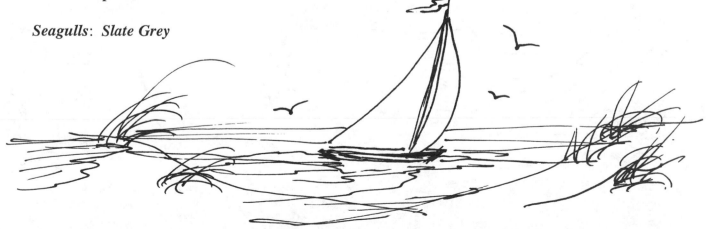

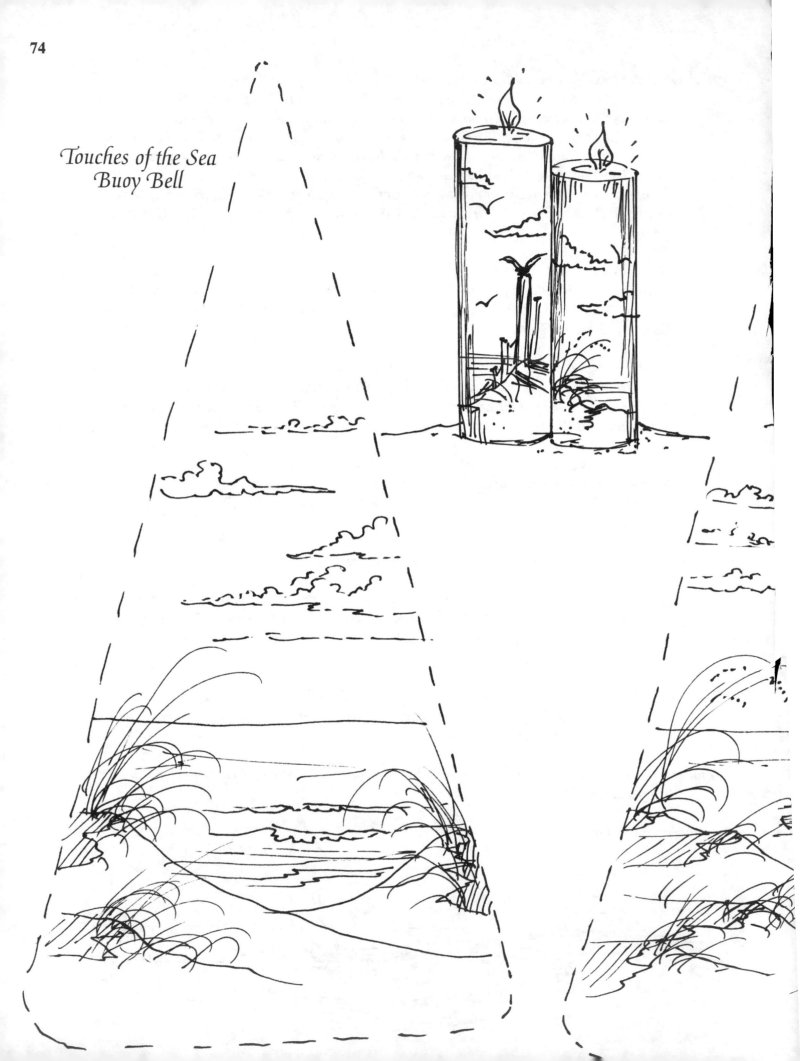

Touches of the Sea
Buoy Bell

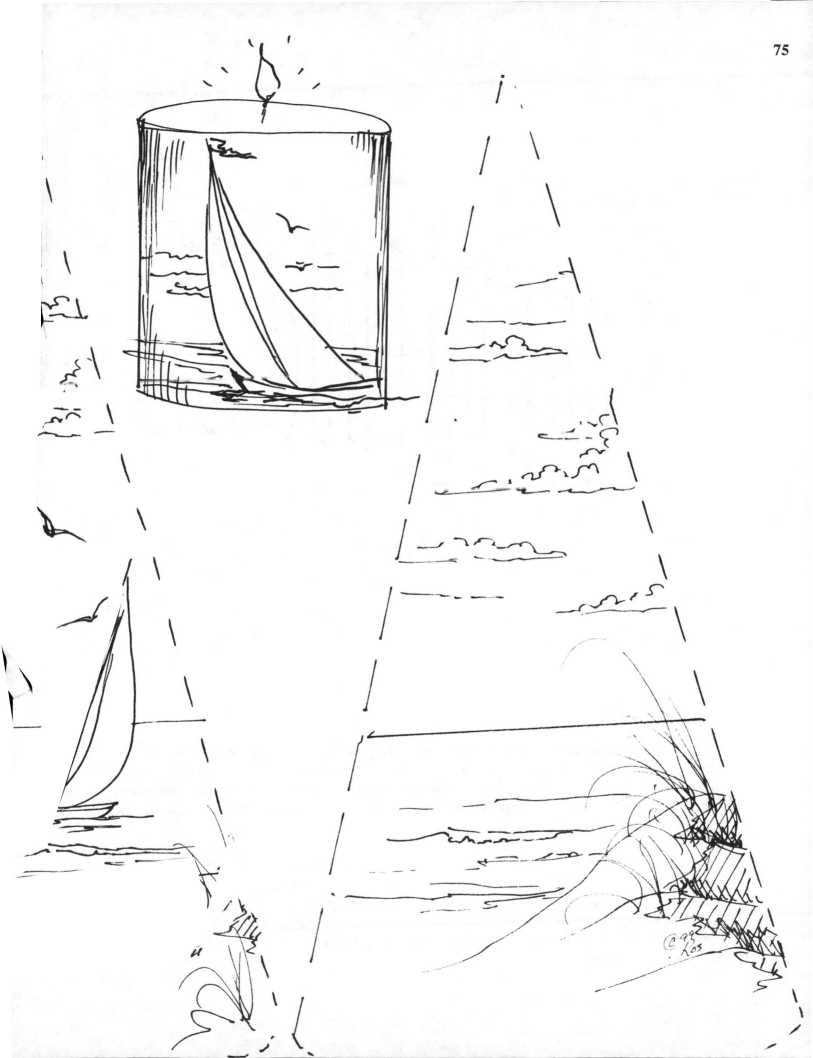

Lettering

Measure and find the center of your board. Draw a light line through this center. Measure where you want the bottom of your letters to be and draw a straight line with a ruler or T-square. Trace letters on to tracing paper, marking the center and adding an underline to use for alignment. Trim and position tracing on top of the pencil lines you have drawn on your board, Anchor with masking tape and transfer with graphite.

Paint letters with a 1/8" One Stroke lettering brush using the color of choice. Pick up a little **Faux Art Glaze** *with your brush. Pull your brush through the paint keeping the hairs flat as you load your brush. Turn your brush over and pull again. Hold your brush on a 45-degree angle as you would a calligraphy pen. Pull strokes to create letters. Do not twist the brush. Hold it at a constant 45-degree angle. Let your brush do the work for you, move your entire arm and keep the pressure constant.*

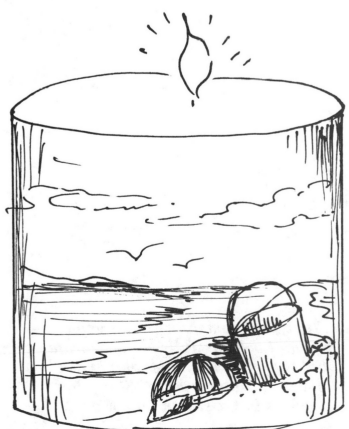

Touches of the Sea
Gentle Breezes
Summer Welcome
top of pattern

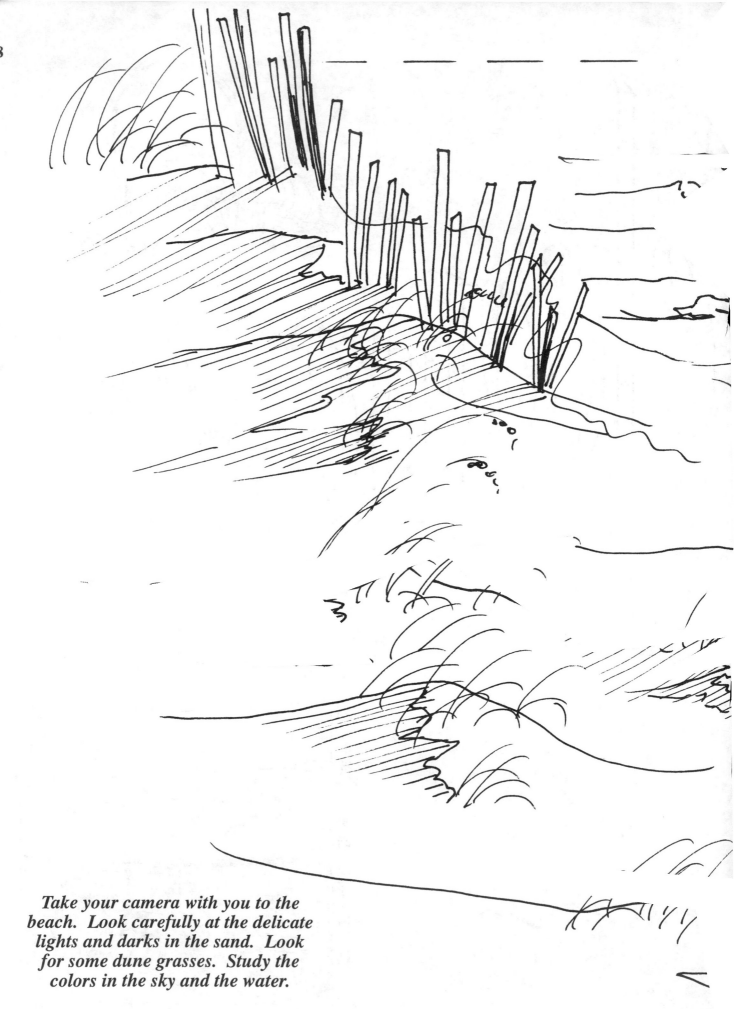

Take your camera with you to the beach. Look carefully at the delicate lights and darks in the sand. Look for some dune grasses. Study the colors in the sky and the water.

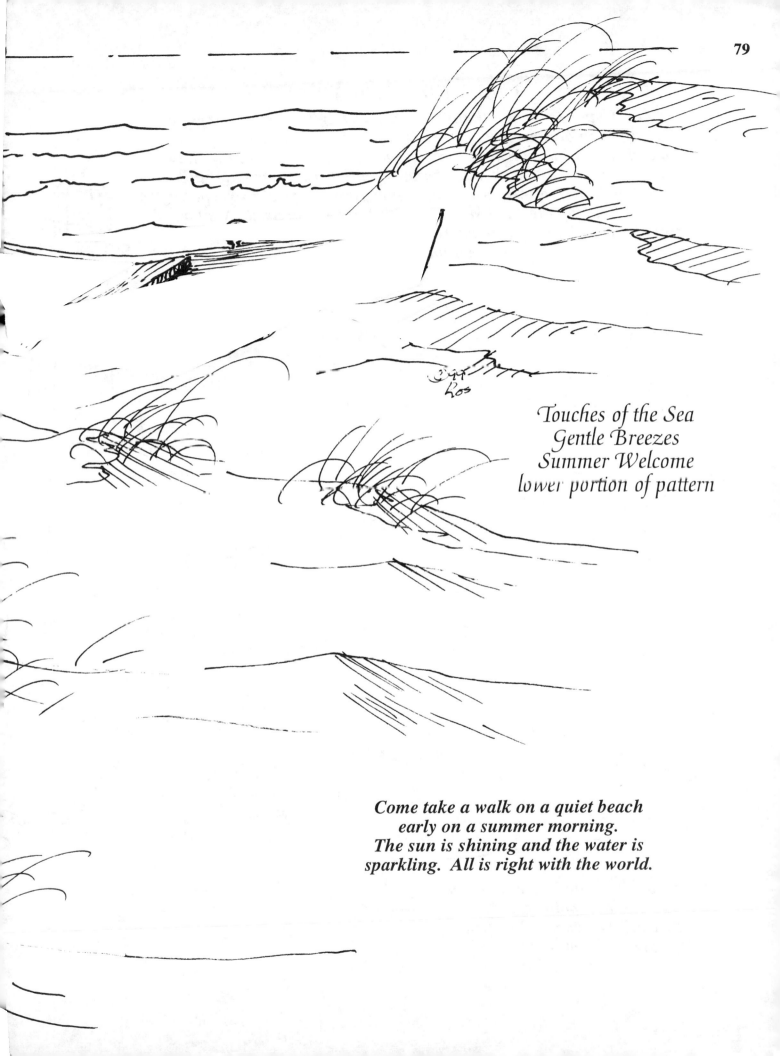

Touches of the Sea
Gentle Breezes
Summer Welcome
lower portion of pattern

**Come take a walk on a quiet beach
early on a summer morning.
The sun is shining and the water is
sparkling. All is right with the world.**

Old Cape Henry

The Old Cape Henry lighthouse is the oldest lighthouse in America having been built in 1792. President George Washington signed the contract for its construction. It is built of stone blocks that had to be imported to the site. It operated until its replacement, built just a few hundred feet away, was commissioned in 1881 except for a period during the Civil War when it's light was doused. Visitors can climb to the top for a magnificent view of Cape Henry and the Chesapeake Bay.

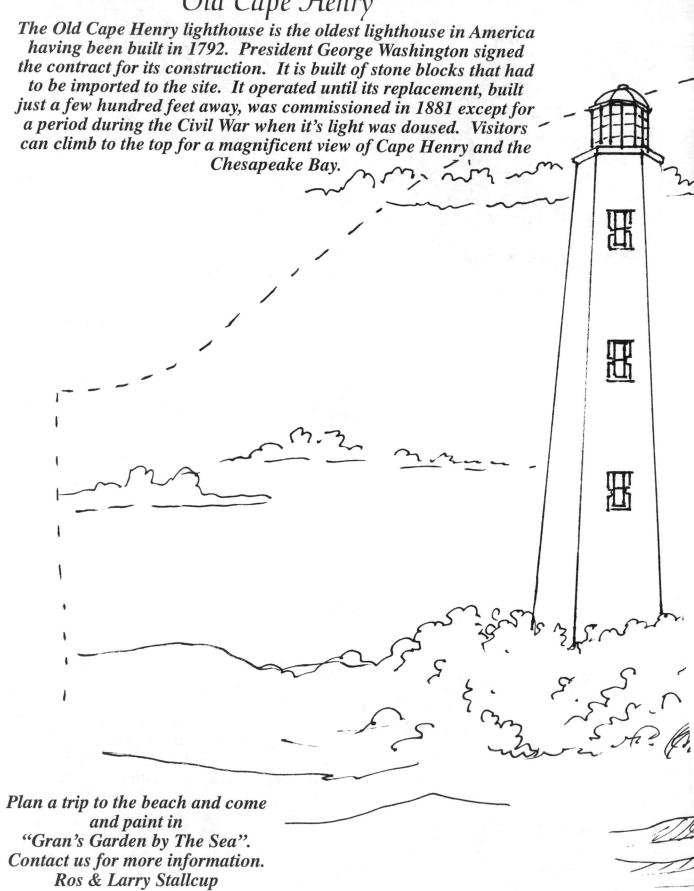

*Plan a trip to the beach and come
and paint in
"Gran's Garden by The Sea".
Contact us for more information.
Ros & Larry Stallcup*

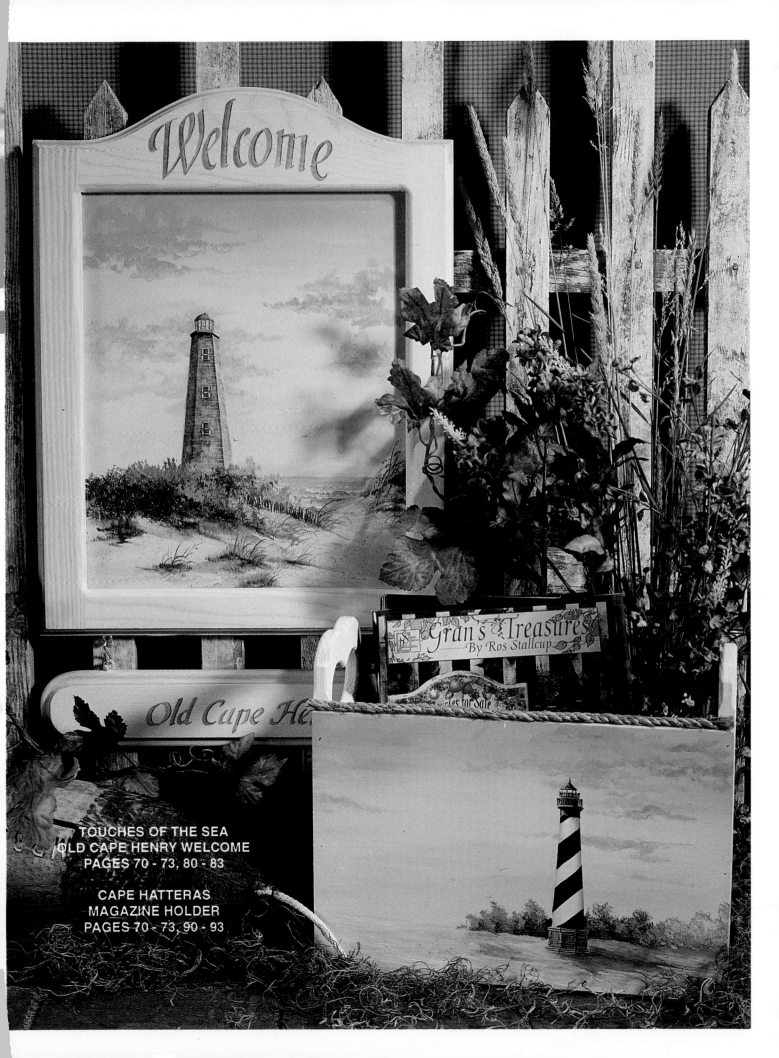

TOUCHES OF THE SEA
OLD CAPE HENRY WELCOME
PAGES 70 - 73, 80 - 83

CAPE HATTERAS
MAGAZINE HOLDER
PAGES 70 - 73, 90 - 93

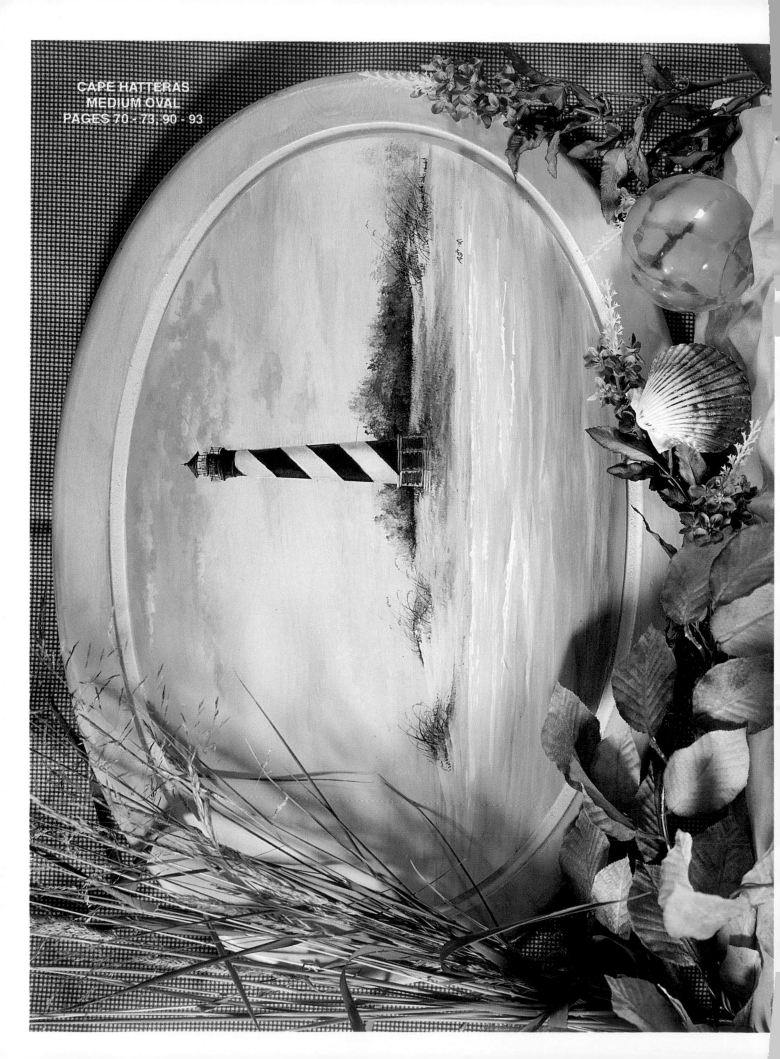

Touches of the Sea
left side of
Cape Henry Sign Board & Welcome

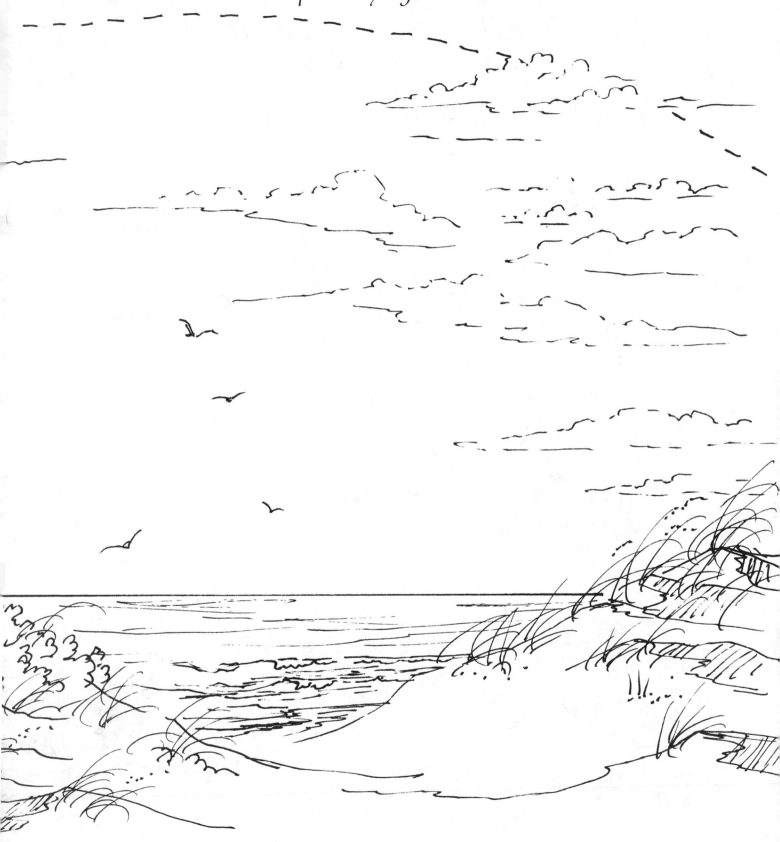

Gentle Breezes

Touches of the Sea
lettering for
Gentle Breezes

Touches of the Sea
Gentle Breezes

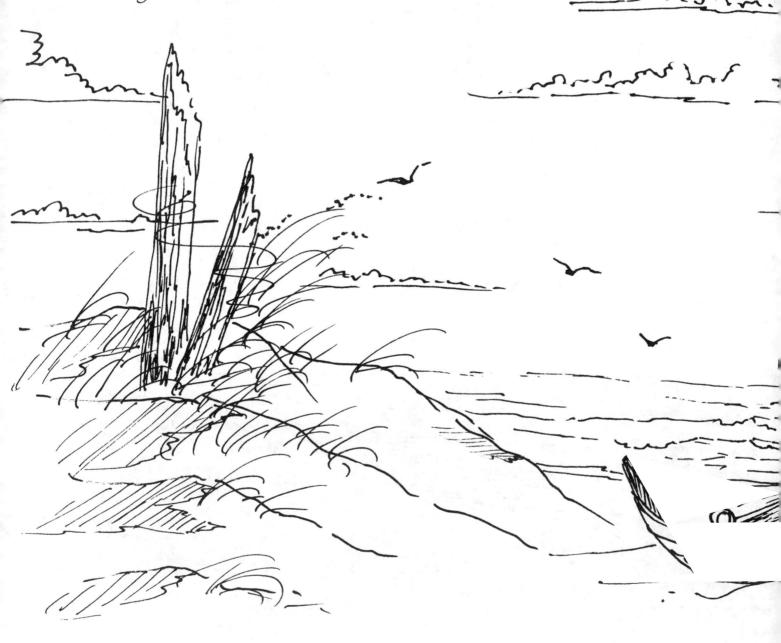

Touches of the Sea
Lettering for
Cape Henry Sign Board

A light
to Guide You

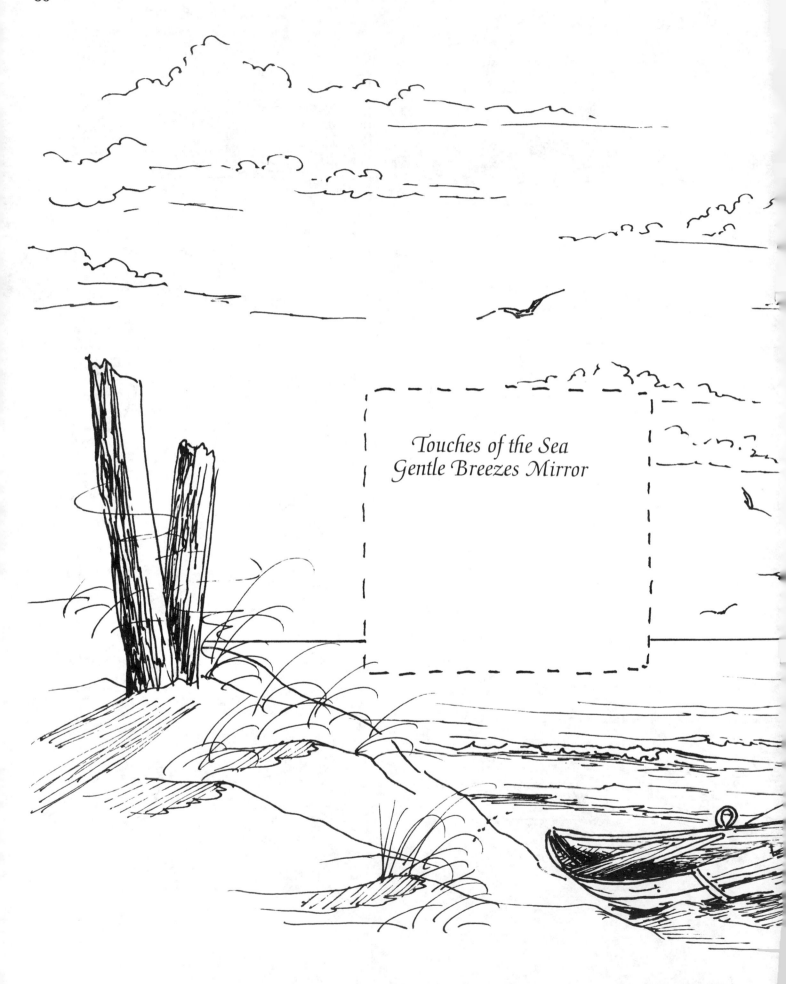

Touches of the Sea
Gentle Breezes Mirror

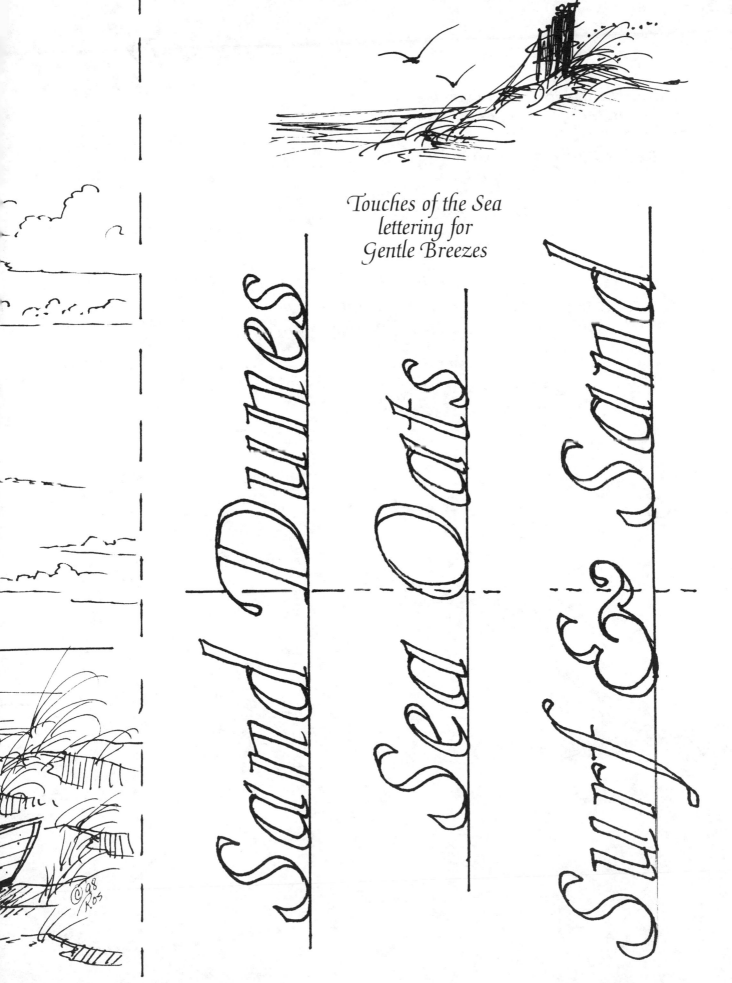

Touches of the Sea
lettering for
Gentle Breezes

Sand Dunes

Sea Oats

Surf & Sand

Beach

The girls and I love to walk on the beach in the spring and fall. We gather magical treasures to save for a rainy day and turn into great works of art.

Touches of the Sea
Beach Stuff
Picnic Basket

Stuff

Add your own magical memories of a trip to the beach. Old sand buckets, beach umbrellas, beach balls and lots of weathered junk.

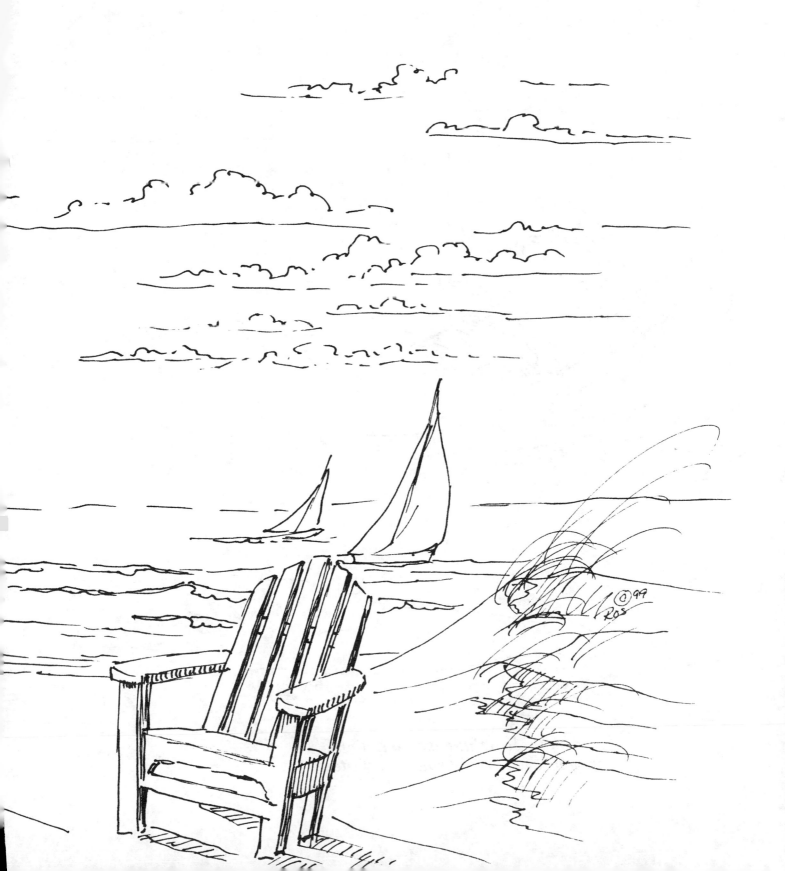

Touches of the Sea
right side of
Cape Henry Sign Board

Ros '98

**Adapt these lighthouses to fit those
in your area or that you have visited.**

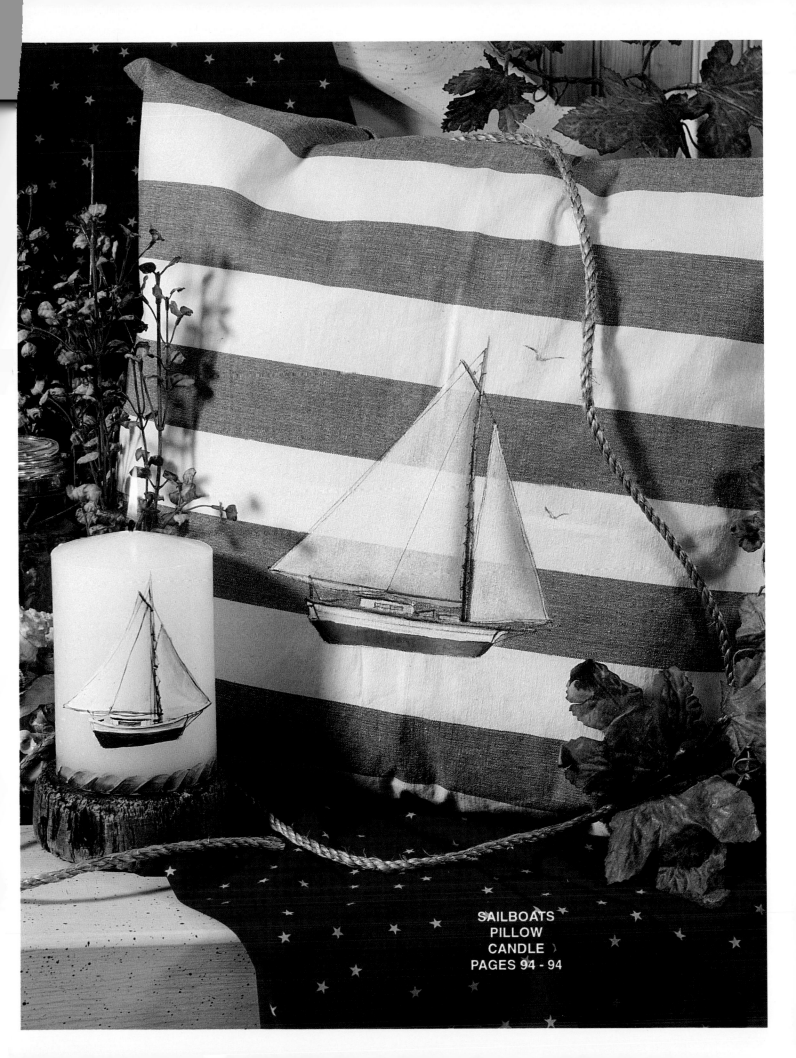

SAILBOATS
PILLOW
CANDLE
PAGES 94 - 94

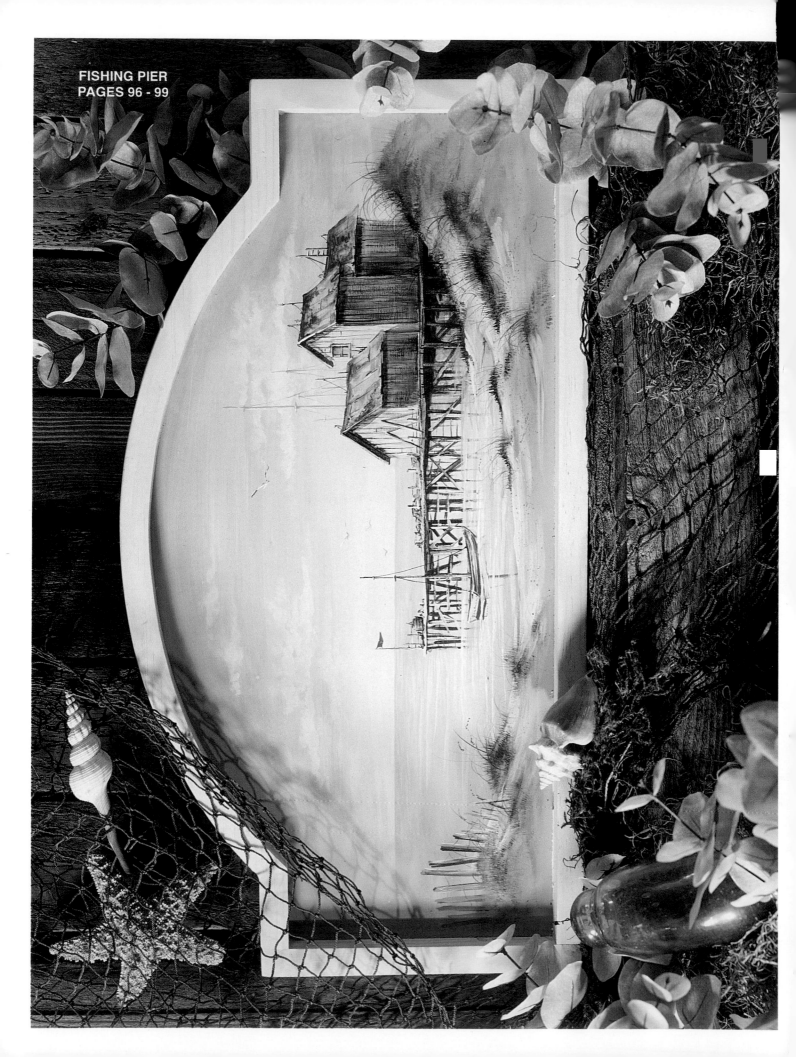

Cape Hatteras

Cape Hatteras lighthouse is a famous national landmark. Its distinctive black and white spiral paint pattern is familiar to both mariners and visitors from around the world. As this book is being prepared for publication a Herculean effort is being made to save it from destruction by the sea. It is being moved inland to a safer site.

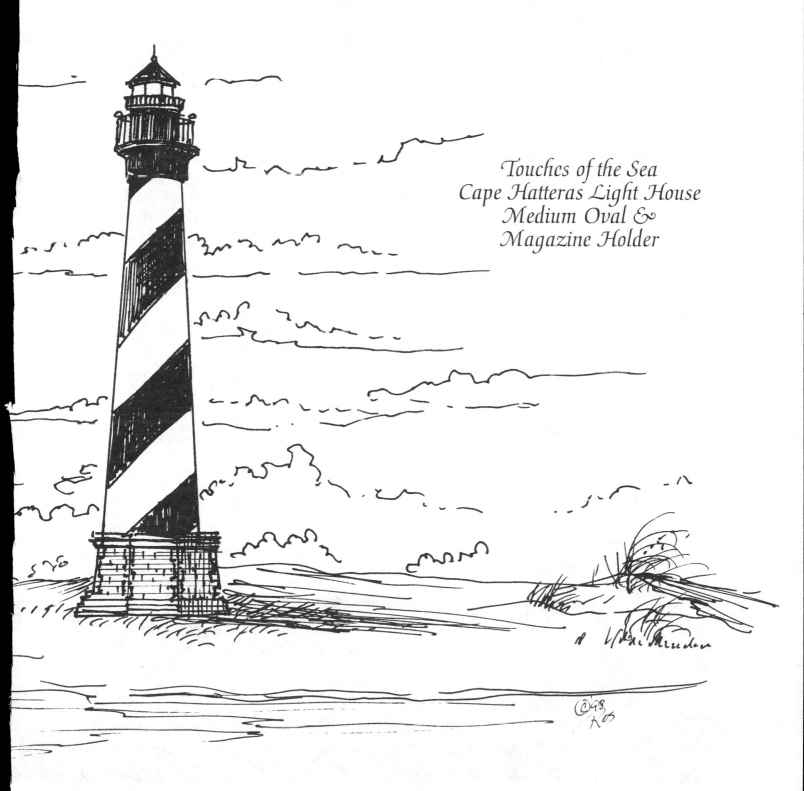

*Touches of the Sea
Cape Hatteras Light House
Medium Oval &
Magazine Holder*

Sailboats

Surfaces: *Pillow (Pottery Barn), Candle*

Paints: **DecoArt Americana Acrylic**
DA001 Titanium White
DA068 Slate Grey
DA167 Paynes Grey
DA219 Heritage Brick

DA064 Burnt Umber
DA093 Raw Sienna
DA184 French Vanilla

Supplies: *Textile Medium or Candle Painting Medium*
.01 Micron Pigma Pen-Black

Pattern: *Trace and transfer pattern with gray graphite.*

Sails and Hull: **Titanium White**. *Shade with* **Slate Grey** *and highlight with* **French Vanilla**. *Deepen color a little in the window area with* **Paynes Grey**. *Paint bottom of the hull with* **Heritage Brick**.

Masts: **Burnt Umber**, *highlight with* **French Vanilla**.

Rigging and Detail: *Draw details with .01 Micron Pigma Pen.*

Paint rope on the candle with **Raw Sienna**, *shade with* **Burnt Umber** *and highlight with* **French Vanilla**.

Sailboat
Candle

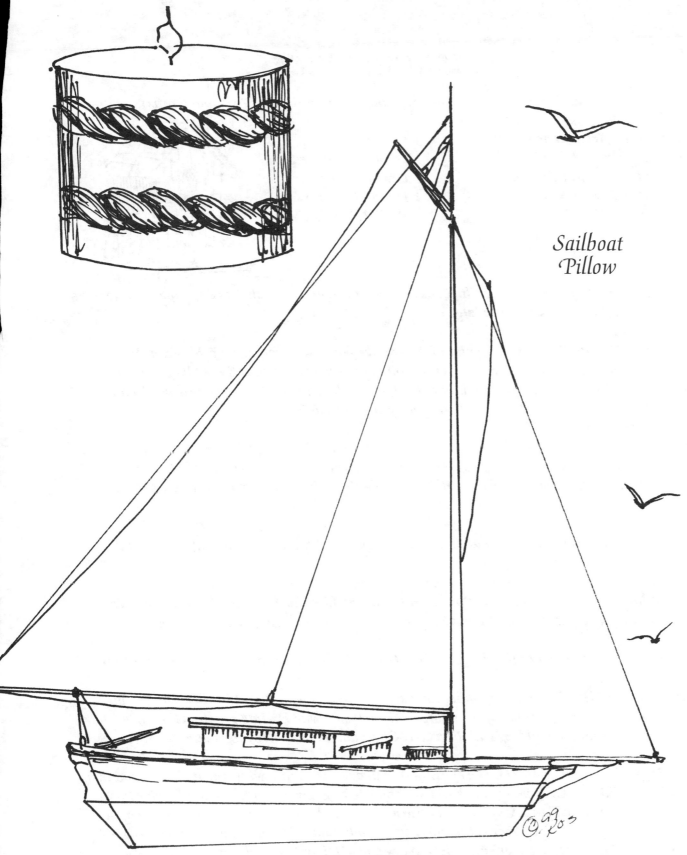

*Sailboat
Pillow*

Ready Made Pillows

*Paint any of the designs in this book on ready-made pillows for a great decorator touch
throughout your home. Coordinate colors and mix and match flowers to suit your
mood. Select fabrics with a smooth tight weave for the best results. Add a little Textile
Medium to your paint and paint like you would on any other surface*

Fishing Pier

Surface: *Medium Goose Creek Sign Board.(Stan Brown's Arts and Crafts)*

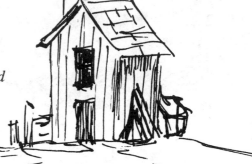

Paints: **DecoArt Americana**
DA024 Hi-Lite Flesh
DA064 Burnt Umber
DA093 Raw Sienna
DA157 Black Green
DA190 Winter Blue
Faux Glazing Medium

DA063 Burnt Sienna
DA068 Slate Grey
DA148 Emperor Gold
DA167 Paynes Grey
DA193 Blue Chiffon

Basecoat: **J.W. White Lightning**. *Tape inside edges of signboard with masking tape to protect the edge. Paint background* **Slate Gray**.

Sky: *Paint* **Hi-Lite Flesh** *in the center of the board. While still wet, pick up* **Blue Chiffon** *blending colors as you go. Progress colors to* **Winter Blue** *then* **Slate Grey** *to create a soft misty effect. Paint clouds with* **Hi-Lite Flesh** *using a small worn brush. Hold the brush overhand and paint with a slightly circular motion.*

Water: *Place masking tape in the sky to create a straight line. Measure or check with a T-Square to keep this line straight. Paint water with the chisel edge of 1/2" angle shader with streaks of* **Winter Blue**, **Blue Chiffon**, **Hi-Lite Flesh** *and* **Faux Art Glaze**. *Edges should fade into* **Slate Grey**.

Pattern: *Trace and transfer the building, the edge of the pier, the sailboat, water edge and sand dunes using gray graphite.*

Distant Mast: **Slate Gray** *highlight on left side with* **Hi-Lite Flesh** *using a liner brush. Draw little fine wires with .01 Pigma Micron Pen and brush glazing medium on top.*

Ladders and Post on top of buildings: **Burnt Umber** *highlight on left side with* **Hi-Lite Flesh**.

Pilings under Pier: *Paint lots of pilings and support boards with* **Burnt Umber** *using a liner brush. Highlight some of the piling on the left side with* **Hi-Lite Flesh**. *Glaze over the area under the building with* **Faux Art Glaze** *and* **Paynes Grey** *to create shadows.*

Building: *Paint walls with* **Slate Grey**. *Streak with dry brush, first with* **Burnt Umber** *and then with* **Paynes Grey** *on the back walls. Streak left light walls with* **Hi-Lite Flesh**. *Paint shadows with* **Faux Art Glaze** *and* **Burnt Umber**. *Wet roofs with water and touch on the wet surface with* **Burnt Sienna**, **Burnt Umber** *and* **Winter Blue** *using the tip of #2 round to create a Tin effect. Allow to dry and detail with board lines, seams in roof using .01 Pigma Pen. Paint* **Faux Art Glaze** *on top to prevent bleeding when you varnish.*

Junk on Pier: *Paint sticks, posts, fence etc. with* **Burnt Umber**. *Highlight with* **Hi-Lite Flesh**.

Fishing Pier continued

Boat and Reflection: *Paint boat with **Hi-Lite Flesh**. Shade side and darken inside of boat with a little **Burnt Umber** and **Paynes Grey**. Paint waterline with **Burnt Sienna**. Paint more streaks in the water with **Blue Chiffon** and **Hi- Lite Flesh**.*

Sand Dunes: *Paint dunes with **Faux Art Glaze** and **Burnt Umber** fading into **Slate Gray** on the edges. Highlight with **Hi-Lite Flesh**. Wet a small area in the dunes and tap and flip up grass on the damp surface with **Black Green** and **Raw Sienna** using the 2/0 fan brush. Paint long line grasses with **Black Green** and **Raw Sienna** using a liner brush.*

Fence: ***Burnt Umber** and **Hi-Lite Flesh**. Glaze over left section of fence posts with **Faux Art Glaze** and **Slate Gray** to fade this area into background.*

Seagulls: *Paint birds with **Slate Grey** using a liner brush. Tip the edge of the wings of the largest one with **Paynes Grey**. Paint a little **Hi-Lite Flesh** across the bottom.*

Spatter: *Spatter sand area only (cover sky with a paper towel) with **Hi-Lite Flesh**, and **Emperor's Gold**.*

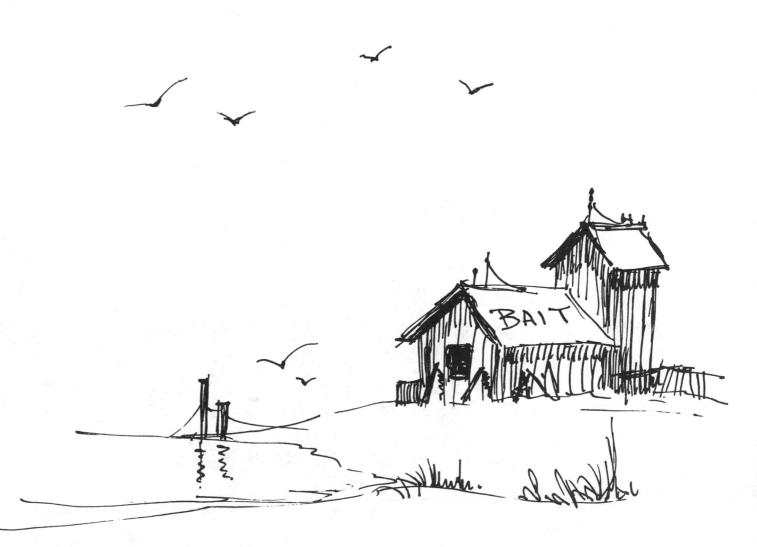

Fishing Pier
attach to left side of pattern

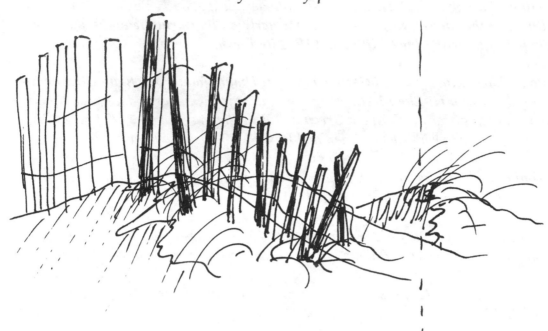

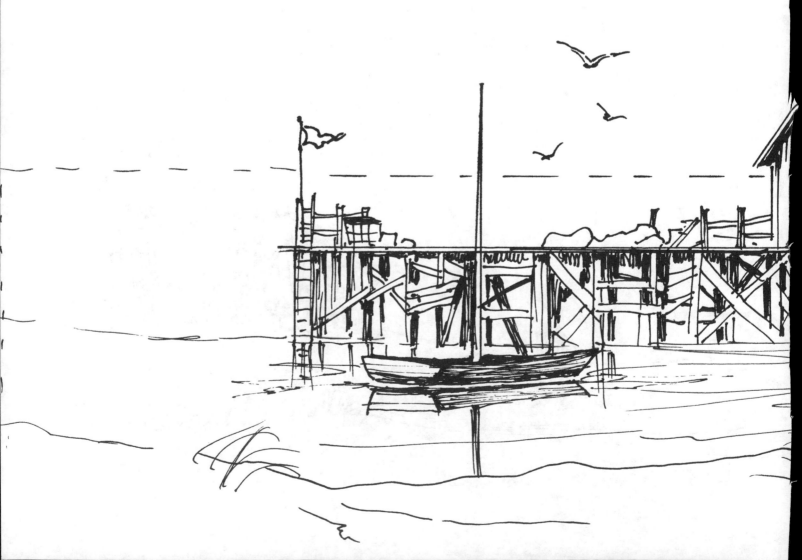

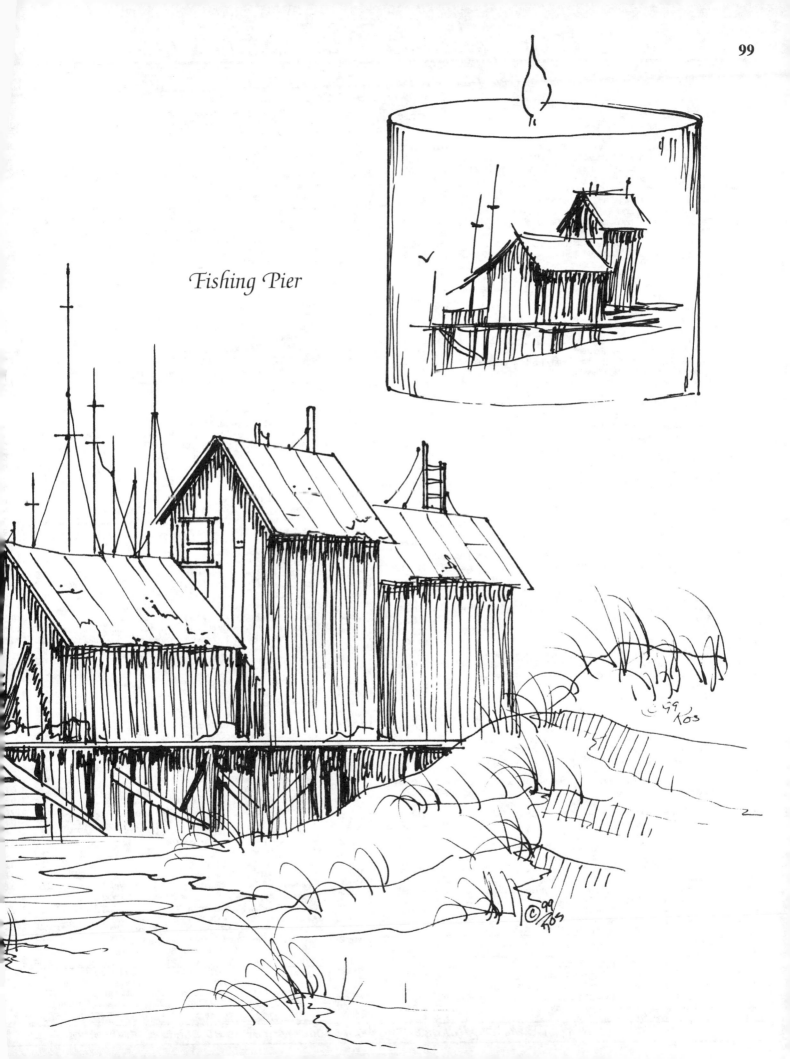

Fishing Pier

ACRYLIC BOOKS

	Title	No.	Price
Vol. 1	"The Garden Path" by Sandi Brady Archer	492	$10.50
Vol. 1	"How Delicious" by Elaina Appleby *NEW*	541	$10.50
Vol. 2	'Country Heartworks 2" by Reed Baxter	365	$10.50
Vol. 2	"The Flower Market" by Joyce Benner	319	$10.50
Vol. 3	"Acrylic Painting The Easy Way" by Bill Blackman	460	$10.50
Vol. 1	"Tole-tilly Tickled" by Lisa Brownie & Gina Knighton	490	$10.50
Vol. 3	"Country Fixin's - For All Seasons" by Rhonda Caldwell	332	$10.50
Vol. 1	"Country Celebration" by Tammy Christensen	378	$10.50
Vol. 1	"Folkart Friends" by Darcy Christensen	437	$10.50
Vol. 1	"Holly Berries and Twigs" by Kim Christmas *NEW*	549	$10.50
Vol. 1	"A Beautiful Journey" by Linda & Michelle Coulter OIL & ACRYLIC *NEW*	555	$10.50
Vol. 1	"Season's Change" by Susan Dircks DeWenter *NEW*	551	$10.50
Vol. 1	"A Painters Garden" by Jane Dillon	354	$10.50
Vol. 3	"A Painters Garden 3" by Jane Dillon	458	$10.50
Vol. 4	"A Painters Garden 4" by Jane Dillon *NEW*	536	$10.50
Vol. 1	"Santas and Sams" by Bobi Dolara	258	$10.50
Vol. 2	"Vintage Peace" by Bobi Dolara	270	$10.50
Vol. 2	"Floral Designs 2" by Carol Empet	338	$10.50
Vol. 3	"Floral Portraits" by Carol Empet	358	$10.50
Vol. 1	"Angels Are Near" by Carol Freeman & Brenda Turley	375	$10.50
Vol. 2	"Briar Patch #2" by Sandy Fochler	424	$10.50
Vol. 3	"Briar Patch #3" by Sandy Fochler	456	$10.50
Vol. 4	"Briar Patch #4" by Sandy Fochler	479	$10.50
Vol. 5	"Briar Patch #5" by Sandy Fochler	506	$10.50
Vol. 1	"Between Friends-Briar Patch" by Sandy Fochler, Lorrie Dirksen, Holly Jespersen, Bonnie Morello	448	$10.50
Vol. 2	"Between Friends 2-Briar Patch" by Sandy Fochler, Lorrie Dirksen, Holly Jespersen, Bonnie Morello	473	$10.50
Vol. 2	"Deck The Halls Bauernmalerei" by Sherry Gall	391	$10.50
Vol. 1	"Pick of The Bunch" by Lola Gill *NEW*	527	$10.50
Vol. 1	"A Bear Necessity" by Denise Girling....CDA *NEW*	550	$10.50
Vol. 1	"Giggles and Hugs" by Sandi Goodman *NEW*	548	$10.50
Vol. 1	"Olde Thyme Folk Art" by Teresa Gregory	390	$10.50
Vol. 1	"Maple Sugar" by Roberta Hall	444	$10.50
Vol. 3	"Maple Sugar 3" by Roberta Hall	471	$10.50
Vol. 4	"Maple Sugar 4" by Roberta Hall	481	$10.50
Vol. 5	"Maple Sugar 5" Country Jars by Roberta Hall	491	$10.50
Vol. 7	"Maple Sugar 7" by Roberta Hall	519	$10.50
Vol. 8	"Maple Sugar 8" by Roberta Hall *NEW*	531	$10.50
Vol. 9	"Maple Sugar 9" by Roberta Hall *NEW*	542	$10.50
Vol. 1	"Endless Seasons" by Tiffany Hastie	498	$10.50
Vol. 2	"Endless Seasons 2" by Tiffany Hastie	521	$10.50
Vol. 1	"Garden Collection" by Bev Hink - Birdwell *NEW*	526	$10.50
Vol. 1	"Artistic Treasures" by June Houck & Veda Parsley *NEW*	535	$10.50
Vol. 1	"Painted Jars" by Conny Hubbard	454	$10.50
Vol. 1	"Happy Heart, Happy Home" by Cathy Jones	241	$10.50
Vol. 1	"Asako's Berry Hill Farm" by Asako Kan	515	$12.95
Vol. 2	"Asako's Berry Hill Farm 2" by Asako Kan *NEW*	524	$10.50
Vol. 1	All Things Possible" by Susan Kelley	512	$10.50
Vol. 2	"All Things Possible 2" by Susan Kelley *NEW*	544	$10.50
Vol. 2	"Dandelions 2" by Carla Kern	513	$10.50
Vol. 1	"Festive Collectibles" by Deborha Kerr "Collectors Release"	279	$10.50
Vol. 2	"Serendipity Collectibles" by Deborha Kerr "Collectors Release"	289	$10.50
Vol. 1	"Painted Memories, A Mother's Love" by Deborha Kerr	435	$10.50
Vol. 3	"Pickets & Pastimes 3, Feathered Inns" by M. & J. King	385	$10.50
Vol. 1	"For Me & My House" by Myrna King	370	$10.50
Vol. 1	"Enjoy The Seasons" By Roni LaBree	510	$12.95
Vol. 2	"Enjoy The Seasons 2" By Roni LaBree *NEW*	538	$10.50
Vol. 1	"Huckleberry Horse" by Hanna Long	269	$10.50
Vol. 2	"Country Favorites" by Hanna Long	489	$10.50
Vol. 3	"Country Favorites 2" by Hanna Long	514	$10.50
Vol. 2	"Love Lives Here" by Mary Lynn Lewis	185	$6.50
Vol. 3	"Love Lives Here" by Mary Lynn Lewis	195	$6.50
Vol. 1	"Everything Under The Moon" by Jackie Ludwig	421	$10.50
Vol. 1	"Second Nature" by Kathy McPherson	427	$10.50
Vol. 2	"Second Nature 2" by Kathy McPherson	463	$10.50
Vol. 6	"Special Welcomes #6 Crop Keepers" by Corinne Miller	347	$10.50
Vol. 7	"Special Welcomes 7" by Corrine Miller *NEW*	543	$10.50
Vol. 4	"Bitterroot Backroads 4" by Glenice Moore	478	$10.50
Vol. 5	"Bitterroot Backroads 5 - Painting Birds" by Glenice Moore	487	$10.50
Vol. 6	"Bitterroot Backroads 6" by Glenice Moore	511	$10.50
Vol. 7	"Bitterroot Backroads 7" by Glenice Moore *NEW*	540	$10.50
Vol. 1	"Fruit & Flower Fantasies" by Joyce Morrison	277	$10.50
Vol. 2	"Fruit & Flower Fantasies 2" by Joyce Morrison	382	$10.50
Vol. 2	"Those Blooming Bears" by Cindy Ohama	493	$10.50
Vol. 3	"Those Blooming Bears 3" by Cindy Ohama *NEW*	523	$10.50
Vol. 4	"Those Blooming Bears 4" by Cindy Ohama *NEW*	547	$10.50
Vol. 1	"Whimsical Critters" by Lori Ohlson	228	$7.50
Vol. 1	"Sunflower Farm" by Lori Ohlson	326	$10.50
Vol. 1	"Seasons Delight" by Jurate Okura	500	$10.50
Vol. 2	"Season's Delight 2" by Jurate Okura	522	$10.50
Vol. 1	"Friends Forevermore" by Karen Ortman	434	$10.50
Vol. 3	"Friends Forevermore 3 - Kitchen & More" by Karen Ortman	509	$10.50
Vol. 1	"Holiday Medley" by Nina Owens	265	$10.50
Vol. 2	"Another Holiday Medley" by Nina Owens	296	$10.50
Vol. 1	"Gifts & Graces" by Charlene Pena	475	$10.50
Vol. 2	"Gifts & Graces 2" by Charlene Pena	497	$10.
Vol. 3	"Gifts & Graces 3" by Charlene Pena *NEW*	534	$10.
Vol. 3	"Tailfeathers 3" by Gisele Pope & Carla Kern	476	$10.
Vol. 8	"Now & Then" by La Rae Parry	428	$10.
Vol. 1	"Between The Vines" by Jamie Mills Price	400	$10.
Vol. 2	"Between The Vines 2" by Jamie Mills Price	419	$10.
Vol. 4	"Between The Vines 4" by Jamie Mills Price	474	$12.
Vol. 1	"Forever In My Heart" by Diane Richards.....AC/Fabric	188	$6.
Vol. 2	"Memories In My Heart" by Diane Richards.....AC/Fabric	189	$6.
Vol. 3	"Forever In My Heart II" by Diane Richards.....AC/Fabric	205	$10.
Vol. 7	"Nostalgic Dreams" by Diane Richards	273	$10.
Vol. 8	"Heavenly Treasures" by Diane Richards	472	$10.
Vol. 1	"Country Classics" by Karen Rideout	413	$10.
Vol. 2	"Country Classics 2" by Karen Rideout	465	$10.
Vol. 1	"Country Fun For Chistmas" by Tina Rodrigues	367	$10.
Vol. 2	"Country Fun 2" by Tina Rodrigues	383	$10.
Vol. 3	"Country At Heart" by Tina Rodrigues	401	$10.
Vol. 4	"Country At Heart 4" by Tina Rodrigues	410	$10.
Vol. 1	"Painting In The Spirit" by Jill Paris Rody *NEW*	529	$10.
Vol. 1	"Kracker Jack Kritters" by Kathie Rueger	405	$10.
Vol. 4	"Keepsake Sampler" by Susan & Camille Scheewe	200	$10.
Vol. 1	"Schoolhouse Treasures" by Cathy Schmidt	408	$10.5
Vol. 2	"Schoolhouse Treasures" by Cathy Schmidt	433	$10.5
Vol. 3	"Schoolhouse Treasures 3 - Blackbird Inn" by Cathy Schmidt	518	$10.5
Vol. 1	"Holiday Hangarounds" by Marsha Sellers	327	$10.5
Vol. 1	"Huckleberry Friends" by Cheryl Seslar	393	$10.5
Vol. 2	"Huckleberry Friends 2" by Cheryl Seslar	403	$10.5
Vol. 3	"Huckleberry Friends 3" by Cheryl Seslar	431	$10.5
Vol. 1	"Kindred Hearts" by Viki Sherman *NEW*	532	$10.5
Vol. 1	"Friendship Creek" by Katherine Smith	496	$10.5
Vol. 1	"Creations In Canvas...and More" by Carol Spooner	256	$10.5
Vol. 1	"Gran's Garden" by Ros Stallcup	295	$10.5
Vol. 2	"Another Gran's Garden" by Ros Stallcup	315	$10.5
Vol. 3	"Gran's Garden & House" by Ros Stallcup	334	$10.5
Vol. 4	"Gran's Garden Party" by Ros Stallcup	345	$10.5
Vol. 5	"Gran's Treasures" by Ros Stallcup	363	$10.5
Vol. 6	"Gran's Gifts" by Ros Stallcup	387	$10.5
Vol. 10	"Gran's Magic-Bells, Books & Candles" by Ros Stallcup	466	$12.9
Vol. 11	"Gran"s Attic" by Ros Stallcup	483	$12.9
Vol. 12	"Gran's Pantry" by Ros Stallcup	508	$12.9
Vol. 13	"Gran's Cottage" by Ros Stallcup *NEW*	533	$12.9
Vol. 14	"Gran's Workbook" by Ros Stallcup *NEW*	552	$12.9
Vol. 1	"Storybook Lane - Harber Boy's Collection" by Sandy Starkel	520	$10.5
Vol. 2	"Blackberry Hollow" by Margaret Steed	407	$10.5
Vol. 1	"Keepsakes For The Holidays" by Charleen Stempel & S. Scheewe	286	$10.5
Vol. 1	"Christmas Greetings from the Cottage" by Chris Stokes	336	$10.5
Vol. 1	"Christmas Visions" by Max Terry	278	$10.5
Vol. 3	"Painting Clay Pot-pourri" by Max Terry	310	$10.5
Vol. 3	"Country Primitives 3" by Maxine Thomas	322	$10.5
Vol. 4	"Country Primitives 4" by Maxine Thomas	350	$10.5
Vol. 7	"Country Primitives 7" by Maxine Thomas	459	$10.5
Vol. 8	"Country Primitives 8" by Maxine Thomas	482	$10.5
Vol. 1	"Rise & Shine" by Jolene Thompson	214	$6.5
Vol. 2	"The Garden Gate" by Jolene Thompson	250	$10.5
Vol. 5	"Count Your Blessings" by Chris Thornton	213	$10.5
Vol. 6	"Share Your Blessings" by Chris Thornton	226	$10.5
Vol. 9	"Blessings" by Chris Thornton	255	$10.5
Vol. 10	"Blessings For The Home" by Chris Thornton	275	$10.5
Vol. 11	"Painted Blessings" by Chris Thornton	323	$10.5
Vol. 12	"Family Blessings" by Chris Thornton	349	$10.5
Vol. 15	"Multitude of Blessings" by Chris Thornton	379	$10.5
Vol. 17	"Blessings For The Home & Garden" by Chris Thornton	423	$12.9
Vol. 18	"Blessings To Treasure" by Chris Thornton	438	$10.5
Vol. 19	"Blessings To Share" by Chris Thornton	470	$10.5
Vol. 20	"Blessings In A Jar" by Chris Thornton	494	$10.5
Vol. 21	"Blessings In A Jar 2" by Chris Thornton	505	$10.5
Vol. 22	"Blessings In A Jar 3" by Chris Thornton *NEW*	546	$10.5
Vol. 1	"Peasantries" by Mary Tiner *NEW*	554	$10.5
Vol. 2	"Farmer and Friends" by Lou Ann Trice	366	$10.5
Vol. 2	"Jars, Jars, Jars!" by Cindy Trombley	469	$10.5
Vol. 3	"Jars, Jars, Jars! 3" by Cindy Trombley *NEW*	553	$10.5
Vol. 1	"Bear's Inn Jars" by Paula Walsh *NEW*	539	$10.5
Vol. 5	"Daydreams & Sweet Shirts II" by Don & Lynn Weed	208	$10.5
Vol. 1	"Pitter-Patter-Pigtail-Girls! A Simpler Thyme" by Stacy Gross West	432	$10.5
Vol. 2	"Country Doodles 2" by Amanda Williams	484	$10.5
Vol. 1	"All Of The Holidays" by Chris Williams	443	$10.5
Vol. 1	"Connie's Favorite Old-Time Labels" by Connie Williams	335	$10.5
Vol. 2	"Connie's Garden Seed Packets" by Connie Williams	351	$10.5
Vol. 1	"Floral Fabrics and Watercolor" by Sally Williams	262	$10.5
Vol. 1	"A Time For Giving" by Evelyn Wright	308	$10.5

VISA
MasterCard

SHIPPING & HANDLING CHARGES
Add $3.00 for the First Book for shipping and handling.
Add $1.50 per each additional book.
Please Add $4.00 for handling & postage. PER TAPES.
Sorry we must have a "NO REFUND - NO RETURN" policy.